Recollections of Dante Gabriel Rossetti and His Circle

AMS PRESS
NEW YORK

Recollections of Dante Gabriel Rossetti and His Circle

(CHEYNE WALK LIFE)

BY THE LATE

HENRY TREFFRY DUNN

EDITED AND ANNOTATED BY

GALE PEDRICK

With a Prefatory Note by William Michael Rossetti

LONDON
ELKIN MATHEWS, VIGO STREET

1904

Reprinted from the edition of 1904, London
First AMS EDITION published 1971
Manufactured in the United States of America

International Standard Book Number: 0-404-02222-7

Library of Congress Number: 73-129379

AMS PRESS INC.
NEW YORK, N.Y. 10003

LIST OF ILLUSTRATIONS

CONTENTS

CONTENTS

EDITORIAL NOTE.

THE position reached and maintained by Dante Gabriel Rossetti in the domain of Art and Poetry, the remarkable influence which he exerted upon the second Renaissance in Art and Letters witnessed by the nineteenth century, and, moreover, the glamour which yet illumines his individuality, and the high esteem in which his accomplishments are justly held, proffer, it is suggested, an ample apology, if such be needed, for rescuing these Recollections from the obscurity of the annals of the family to which the author belonged, and giving them the publicity of print.

Whatever pertains to the mission and conquests of a man of genius—his ideals, methods, and struggles—is of great and permanent value. It necessarily commands universal respect, and sometimes should evoke emulation. But at the same time such knowledge, generally speaking, is beyond the understanding of the non-scientific and insufficiently-versed mind. It is the *human* side of genius which receives the widest comprehension, and

appeals with the larger force to our sympathies, which in fact reveals, through its frailties and idiosyncrasies, the *kinship* of genius with mediocrity and ineptitude, and indeed, enables us to understand more fully the incidence of genius.

By reason of the homely and personal touches which he is qualified to give, the experiences and knowledge gained of an individuality by a constant and observant companion reveal, when related, far more convincingly than any official life based upon correspondence or posthumous compilation could do, the character, the humanity of the subject. And hence, whatever value these Recollections may possess as such, their chief lies in the fact that they convey the personality, and describe the thoughts and actions of the great poet-painter as they appeared to one long privileged to enjoy familiar association with him, and who had consequently unique opportunities for gauging his weakness as well as his strength.

That they have also a certain illuminating value will, I think, be conceded. It is not difficult to imagine ourselves, as we read, silent but welcome guests at those brilliant gatherings which are so vividly described, to conjure up the dominating figures in Art and Poetry

with whom we are brought so frequently into contact, to listen to the sparkling conversation and the flow of wit and reason, or to laugh at the smart repartee; neither is it hard to realise that power of inspiring enthusiasm and making proselytes which Rossetti possessed in so marked a degree, nor the extraordinary magnetism of his complex individuality.

Viewed solely from the literary standpoint, that these memories have a certain charm and quality in this regard, will not, I think, be denied.

I wish to acknowledge the great indebtedness of the surviving sisters of Henry Treffry Dunn and my wife, his niece, as well as of myself, to Mr. William Michael Rossetti for kindly correcting the manuscript of the Recollections and affording valuable information concerning points which were undefined; also, for penning an introductory note, and generously placing at my disposal for the purpose the originals of the illustrations which appear in this volume, and to express to him their and my warm thanks for his interest and generosity.

GALE PEDRICK.

110, St. Martin's Lane, London.
September, 1903.

PREFATORY NOTE BY WILLIAM MICHAEL ROSSETTI.

HAVING been invited to write a few words of introduction to the reminiscences of my brother, Dante Gabriel Rossetti, left by Mr. Henry Treffry Dunn, I very readily assent. I was personally cognizant of most of the circumstances here related, and am therefore qualified to state whether this account of them is or is not a genuine contribution to my brother's biography.

I have no hesitation in saying that it is perfectly genuine, and gives, from the writer's point of view, a very fair notion of what Dante Rossetti did in those years, and what he was like. The narrative was not known to me until May last, when a transcript of it was produced to me by Mrs. Hume, a sister of Mr. Dunn. I read it with satisfaction, and made, on points of detail, various observations to which the Editor, Mr. Gale Pedrick, has been so good as to pay heedful and ample attention.

It will be apparent to the readers of this narrative that in the years which it covers, Mr. Dunn saw as much of Dante Rossetti as any other person whatsoever did, or indeed more, if one looks to continuous day-by-day association. He witnessed his comings-out and goings-in, and was highly familiar with his methods of work as a painter. Every look of his countenance, every intonation of his voice, every mood of his temper—sunny, overcast, or variously shifting—was known to the narrator.

My own acquaintance with Mr. Dunn covered the whole period of his connection with my brother, and extended to a couple of years or so beyond the death of the latter, April, 1882. After that date, as it happened, I did not meet him again. I had a very sincere regard for Mr. Dunn, perceiving him to be upright and straightforward in all his dealings, a valuable professional auxiliary for my brother to have secured, and always anxious to serve Rossetti's true interests in matters outside the pictorial range. He did a good deal towards keeping things straight in an establishment where the master's rather unthrifty and negligent habits in household affairs might easily have made them crooked. Mr. Dunn was a pleasant and helpful companion, conversant with several

matters unrelated to the artistic career. I should have liked to see a portrait of him in this volume. In default of that, I may say that he was a man of middle height, with a narrow visage, a rather dark but ruddy complexion, dark, telling eyes, and a full crop of hair, prematurely grey.

LONDON, *September*, 1903.

BIOGRAPHICAL NOTE OF HENRY TREFFRY DUNN.

HENRY TREFFRY DUNN, the author of these Recollections, was born at Truro, in 1838. For some time he was engaged as a clerk in the Cornish Bank of his native city, but when about twenty-four years of age, the artistic instinct strong within him, he abandoned the desk for the palette and brush, and adopted painting as a profession. Soon after, as he himself relates, he received an introduction to Dante Gabriel Rossetti. At once he was irresistibly attracted by the magnetism which formed one of the most noteworthy facets of the personality of that poet, painter, and leader of men, and came under the spell of that influence which he possessed over all around him, and none were ever able or willing to liberate themselves from. He forthwith took up his residence with Rossetti. Many years of close comradeship and daily intercourse followed between the chief and his disciple, and it was the good fortune of the latter, during this period, to meet on terms of intimacy those men of distinction—the

record of whose achievements constitutes the history of Poetry, Art, and Letters in the nineteenth century—whom Rossetti collected around him, and to be constantly present at those frequent and prolonged meetings in the dimly-lit studio at Cheyne Walk, which were famous for their intellectual charm and brilliancy.

Henry Treffry Dunn was himself a painter of no mean ability, but for the most part he was content to remain under the shadow cast by the towering genius and capacity of the master. One of his works hangs in the council chamber of his native city—a portrait of Dr. Barham.

As may be gathered and inferred from his Recollections, in common with all who enjoyed his friendship he felt a deep affection for Rossetti as a man, and a profound admiration for him as a poet and painter. He is expressly mentioned by Mr. William Michael Rossetti as one of his brother's friends in the Preface to the *Collected Works of Dante Gabriel Rossetti*. He died in February, 1899. Both he and his chief have long since solved the tremendous mysteries of life and death, upon which they were wont so often to speculate together.

Editor.

RECOLLECTIONS

Chapter I.

A premonition—a trip to Holland—James Shepherd—Heatherleys—William Gorman Wills—Charles Augustus Howell—Two portraits of Dante.

Several years ago, when discharging the duties of a clerk in a banking establishment (located in the extreme west of England) in a somewhat listless fashion, one or two associates and myself regularly subscribed for the *Illustrated London News*. One item contained in a particular issue of that journal remains indelibly engraven upon my mind. Whilst studying its contents on the morning of its arrival, during the ten minutes grace allowed us after the mid-day meal, I recollect seeing a paragraph containing a quotation from a letter which had appeared in a recent number of the *Athenæum*. This was to the effect that Mr. D. G. Rossetti had not given up oil for water-colour, but that he still practised both. As far as I could then see, the intimation in no way affected me. I was simply attracted by it through the keen interest I felt towards painting, and a yearning long experienced to adopt Art as a profession.

" D. G. Rossetti ? " I enquired of myself—" why, I never heard of him. Who is he ? and what kind of pictures does he paint ? "

Thereupon I fell into a reverie over the announcement I had seen, and gradually and convincingly a strange presagement came to me that some day, not very far off, I should not only meet and know this man, but even be closely associated with him in his profession.

Months elapsed; summer began to wane, and I to make preparation for my annual fortnight's holiday. I had a great desire for a long time to see something of Holland, and by dint of economy I had managed to put sufficient together to enable me to realise it. I also determined, if the limited time of my interval allowed, to obtain a glimpse of the Rhine. I got to London, and, with the aid of a *Bradshaw*, made out the route to Harwich. There I took the steamboat, and after a night's voyage, which was somewhat rough and tempestuous, I landed at an early hour in the morning in the Boompjes at Rotterdam.

To get something to eat was my first consideration, and after wandering vainly about the streets for some time in search of a place of refreshment, I at last espied a coffee-tavern. Unaware that Dutch was the prevailing language of the greater part of the inhabitants of Rotterdam, I fancied there would be no difficulty in making known my wants with the few phrases of French and German that I had managed to pick up, but

I was soon to be undeceived. Entering the house, I seated myself at the nearest table and rang for attendance. Presently, a slovenly, unkempt girl, broad of face, made her appearance, and in what German I could command I asked her to provide me with some breakfast. She nodded her head, stared in bewilderment, and said something in reply which was perfectly unintelligible; so, my German failing, I tried again in the few words of French I could remember. This seemed even more perplexing to her, and shaking her head once more, she went away with a grin on her expansive face. Anon, she returned with her mistress, who was even more fat and "Dutchier" looking than the maid, and both stood with their arms akimbo gazing at me with curiosity. Again I essayed to make myself understood, but only to find that in language the effort was fruitless. Suddenly a happy thought struck me. Pulling out my sketch-book, I hastily drew a plate with a chop on it, a knife and fork, a couple of eggs, and a cup and saucer. To their delight, this gave them a clear idea that it was something to eat and drink that I wanted, and in a very short time I was furnished with a substantial and well-cooked meal.[1]

I lingered for some days about this delightful old Rotterdam, sketching its quaint nooks and corners here and there, and then took a hasty run up the Rhine, as far as Mayence. My time, however, was getting short, and reluctantly I had to think of returning home again. On the return journey there were a good many tourists—

homeward bound like myself—on the boat. One of them, James Shepherd,[2] took an interest in my sketches. He entered into conversation with me, and when I expressed a strong desire to adopt Art as a means of obtaining a livelihood, he encouraged me in the idea, and assured me, that if I ever went to London with that intention he would give me all the assistance he could. I noted the address which he gave me, and promised to make use of it as soon as circumstances allowed.

A year afterwards I finally resolved to take my chance as an artist, and to follow Art altogether. Accordingly, I gave up my situation in the bank, and soon made my way once more to London, when I entered myself as a student at a nursery for beginners, known as "Heatherley's."[3] Here quite a new life opened to me, and here I found quite a fresh and more congenial set of companions. One of them was the late William Gorman Wills[4]—he had not then written his *Charles I.*,[5] which was to place him in the first rank as a dramatist—with whom I formed a close friendship which lasted until his death.

As yet I had earned nothing, and as my funds were beginning to run low, I bethought me of my Rhine friend's promise of assistance. I resolved to call upon him and acquaint him with my position, which I did without further loss of time. He received me very cordially, and before I left gave me an introduction to Charles Augustus Howell,[6] an intimate, so my friend informed

me, of Dante Gabriel Rossetti, who he thought might be persuaded to do something for me in the way of employment. Upon hearing the name of Rossetti mentioned, I instantly recalled the announcement I had once seen in the *Illustrated London News*, and the premonition I had then received, and felt that what was then so strangely presaged was actually about to come to pass.

I lost no time in writing to Mr. Howell. In reply, he invited me over to Brixton, where he resided, to lunch with him, when my work and capabilities could be fully discussed. And taking with me a few sketches of what I considered most likely to find favour in his sight and pave my way to a meeting with Rossetti, I accordingly found myself at Brixton by the time appointed.

Mr. Howell received me with great kindness, and was so genial and so encouraging in his criticism, that I soon felt quite at my ease and most sanguine as to the future. Lunch was followed by a cigarette and a very pleasant chat, in the course of which I gathered much about Rossetti, as well as concerning John Ruskin.

As a start, my host gave me a commission to make facsimile copies of two heads of Dante that were in his study, but the owner of which was Rossetti. The history of these heads, as related by Howell, was both curious and interesting to me, since it opened up a field of literature and art of which I was hitherto almost ignorant. The first was a copy of a fresco discovered by Baron Seymour Kirkup[7] in an old chapel at Florence[8]

(where for a couple of centuries or more it had lain hidden under repeated coats of whitewash), which had been drawn from the poet himself by his friend Giotto, who is alluded to in his *Purgatorio* as the coming rival of Cimabue.[9] The second was a copy of an old Italian oil, or rather fresco painting, of the same period judging from the style of work, by an unknown artist.

Both paintings were most characteristic, and required very careful reproduction, but I managed this successfully enough to please Rossetti and make him wish to see me, and, an early day having been arranged, I called upon him.

Chapter II.

My appointment took me, for the first time since I had been in London, to Cheyne Walk, Chelsea, in one of the most picturesque houses of which Rossetti lived.[10] Entering by the fine old gateway of seventeenth century ironwork, before ascending the flight of stone steps leading to the street door, I paused for a moment to look at the house itself. A profusion of jasmine in full bloom spread over the lower part of its walls, and it gave me the impression that at one time it must have formed the central portion of a much larger and statelier mansion. A large old-fashioned knocker in the shape of a dragon adorned the street door. I found, however, it was not a very easy dragon to perform a respectable *rat-tat* upon, by reason of the awkwardness of its shape (I did not quite know whether to take it by its head or tail) and the stiffness in its joints which age had rendered.

On gaining admission, I was ushered into one of the prettiest, and one of the most curiously-furnished and old-fashioned sitting-rooms that it had ever been my lot to see. Mirrors of all shapes, sizes and designs, lined the

walls, so that whichever way I gazed I saw myself looking
at myself. What space remained was occupied by pic-
tures, chiefly old, and all of an interesting character.
The mantelpiece was a most original compound of
Chinese black-laquered panels, bearing designs of birds,
animals, flowers and fruit in gold relief, which had a very
good effect, and on either side of the grate a series of old
blue Dutch tiles, mostly displaying Biblical subjects
treated in the serio-comic fashion that existed at the
period, were inlaid. The fire-grate itself was a beauti-
fully-wrought example of eighteenth century design and
workmanship in brass, and had fire-irons and fender to
match. And in one corner of the room stood an old
English china cupboard, inside of which was displayed a
quantity of Spode ware. I sat down on a cosy little sofa,
with landscapes and figures of the Cipriani period painted
on the panels,[11] and whilst admiring this curious collec-
tion of things the door opened behind me, and, turning
round, I found myself face to face with Dante Gabriel
Rossetti.

It was in the month of June, 1863,[12] that this, my
first meeting with Rossetti, took place. He must have
been then about 35 years of age.[13] His face conveyed to
me the existence of underlying currents of strong pas-
sions impregnated with melancholy.[14] His eyes were
dark grey, and deeply set; the eyebrows dark, thick, and
well arched; the forehead large and well rounded, and
the strongly-formed brows produced a remarkable fulness

at the ridge of the nose, such as I have often noticed in men possessed of great individuality. A thick, but not heavy moustache partly concealed a well-formed and somewhat sensuous mouth, and at this time he wore a trimmed beard of a deep chestnut brown, with the cheeks shaven; his hair was much darker in colour, curly, and inclined to thinness. He was about 5 feet 7½ inches in height—his drawing-room door was a faithful recorder not only of his own stature but that of most of his intimate friends. Although there was a tendency to a rather too extensive form with him, this was not particularly noticeable, owing to his shapely figure and easy carriage. He possessed a voice which was peculiarly rich and musical in tone; and when, later, I had opportunities of hearing him read his poems, which he did from time to time to some of his intimate friends, it was delightful to listen to him. His hands were small and very white.[15] Of jewellery he made no display; all that he wore was an old-fashioned gold chain attached to his watch. He was equally unassuming in dress. For studio use he generally wore a loose overcoat, with capacious pockets into which he could easily thrust a good-sized memorandum book, which was indispensable to him, as it was his custom to jot down his thoughts either for poetry or painting as they arose in his mind.

Rossetti invited me into his studio, a large and roomy apartment, well lighted, and liberally stocked with Chippendale chairs and lounges, and various other inviting

rests whereon one might sit at ease and enjoy a survey of his pictures, which stood about on easels. Several cabinets of old English and Spanish design and workmanship filled up the odd nooks and corners that were left.

Inviting me to look at what he was then engaged upon, Rossetti drew my attention to his painting of *Lady Lilith.* It was the portrayal of a beautiful woman, sumptuously seated in some mediæval kind of chair, combing out a cataract of golden hair that fell in masses over her shoulders. By her side was a mirror of curious form, in which was reflected the greenery of the forest glade, through which the glinting sunlight pierced here and there, lighting up the densely-leaved branches of the trees, and a large red double poppy in a goblet of old Venetian glass stood near her. The dreamy beauty of the woman, and the rich colour in which the whole picture was steeped excited my admiration.[16] I desired to know its meaning, and in answer to my enquiry he told me it was suggested by Lilith.

"Who was she?" I asked.

Rossetti then told me the Talmudic legend concerning her,[17] and then I understood the allusion to her in *Faust*, where Goethe introduces Lilith into the witch scene on the Hartzbrocken, and makes Faust ask the same question in almost the same words that I had used.[18] I am sorry to say Rossetti repainted the face some years later, for what reason I could never divine, and to my thinking he by no means improved upon the original.

Generally speaking, I hold it a dangerous experiment to alter a first conception; the charm, the quality of colour, and the inspiration are so apt to be lost.[19]

Other works, both in oil and water-colour, were about the studio. One of them that attracted my attention very much was the touching picture, *Beata Beatrix*,[20] which was presented to the National Gallery by Lady Mount Temple[21] after the death of Rossetti. I afterwards learnt from my friend Howell that the face of Beatrice was painted from Mrs. Rossetti, who had died some time in the previous year.[22]

There was yet another of his works that incited my interest. He called it *The Loving Cup*.[23] Rossetti wanted a replica made in water-colours, and it was on this that he wished me to make my first essay.

Although I was in considerable doubt as to whether I could do it or not—his water-colour work was so different in method of execution to anything I had yet seen—I was delighted with the opportunity afforded me, and said that I would try, so arrangements were made there and then for me to come and make a beginning. The beginning, I am happy to say, came to a good ending. Rossetti liked my replica so well, that when it was completed he set me to work upon something else.

Chapter III.

To return to Rossetti and the studio. His well-stocked Chippendale bookcase suggesting, I suppose, we began to converse upon books and then about William Blake[24], for whose works I had a great reverence and admiration. Observing this, Rossetti went to the shelves and took down a little, unpretentious volume that looked just like a schoolboy's exercise book. Such it was originally intended to be, but the use to which it had been put made it very precious in my sight, for on turning over the leaves I saw it was filled with Blake's first thoughts for his *Songs of Innocence*, interspersed with pen-and-ink and slightly-coloured pencil designs for the same.[25] Rossetti told me he had bought the book many years previously[26] from one of the attendants in the British Museum, who had let him have it for half-a-sovereign, and it was from this manuscript collection that the

recently published edition, over which he and the late Alexander Gilchrist[27] collaborated[28] had its origin.[29] This rare little book fetched over one hundred guineas at the sale of Rossetti's effects which took place after his death.

When the Blake manuscript was well conned and discussed, another curiosity took its place, in the form of *Hypnerotomachia Poliphili*,[30] of great interest to book collectors, because the numerous woodcuts illustrating the text are said to have been designed by Botticelli.[31] Rossetti's copy was faulty, as it lacked the original title-page and binding ; but this did not interfere with my enjoyment of the designs. Many other books there were in that Chippendale case of a similar kind, such as the *Nuremberg Chronicle*, with its quaint and interesting illustrations.

As the afternoon wore on, William Michael Rossetti,[32] the painter's brother, came in. He generally spent three evenings a week at Cheyne Walk. I had heard and seen his name pretty frequently in connection with critical papers upon Art which had from time to time caught my eye in some of the periodicals that came in my way. William Michael Rossetti I soon got to like, and as he was a smoker it gave me an opportunity of producing my pipe and blowing a cloud with him. A special tobacco box, always on the mantelpiece, was reserved for William Michael Rossetti, who invariably brought a two-ounce packet of some choice brand of

tobacco which generally disappeared by the time his next visit came about. A good many of the visitors to Cheyne Walk were smokers, and if their own stock ran short, William Michael Rossetti's was usually drawn upon. The box itself was a bit of 18th century pewter work, four-square shaped, designed in high relief with sporting and rural scenes. I always intended to make a cast of it for my own use, and as a memento of the house, but never did so.

Rossetti's fancy for collecting old blue Nankin and other china was just at this time in full swing. James McNeil Whistler[33] had set the example with his " Long Elizas,"[34] and was closely followed by Rossetti and Howell. Each tried to outvie the other in picking up the choicest pieces of " Blue " to be met with. A pair of splendid blue hawthorn ginger pots stood on a table in the studio. These were not the first ginger pots I had seen ; I recollect that when a boy they were common enough—of course, not such magnificent specimens as these were, but very good ones—although they were then thought very little of, and many a one such as would fetch ten or fifteen shillings now were given away to anybody who chose to ask for them. The two haw-thorn pots in question were certainly beautiful, and ex-quisite in their blue and design, nevertheless when Rossetti informed me he had paid sixty pounds each for them, I confess I was astounded. The investment, how-ever, proved a good one, as some time later, when money

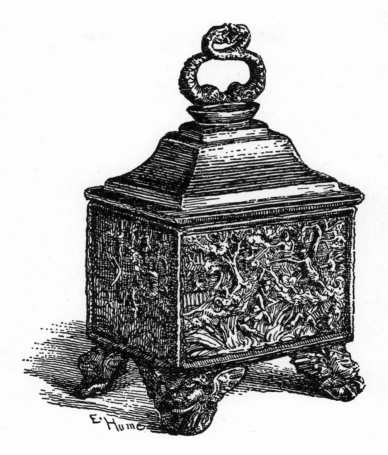

THE TOBACCO BOX.

was needed, the pair was disposed of for six hundred pounds.[35]

Whilst the hawthorn pots were being admired and discussed, Rossetti was hastily pulling out drawer after drawer from an old cabinet that stood in one of the recesses of the room. He was searching for something suitable to paint round the neck of the girl in his picture *The Loving Cup*, and before him lay a rare store of necklaces, featherwork, Japanese crystals, and knick-knacks of all kinds, sufficient to stock a small window. At length his choice was made of a necklace, and when this was satisfactorily settled, his costumes, which were kept in a large wardrobe at the back of the studio, were overhauled for one that was needed for another painting which he had in progress.

In going towards this wardrobe, I noticed upon one of the walls of the studio a gilt frame containing about half a dozen drawings and sketches, chiefly by members of the Præraphaelite Brotherhood,[36] with the names of John Everett Millais,[37] William Holman Hunt,[38] Thomas Woolner,[39] William Bell Scott,[40] Ford Madox Brown,[41] and James McNeil Whistler attached.

Wherever I went, I noticed musical instruments of some kind or another; all were old and mostly stringed—mandolines, lutes, dulcimers, and barbarous-looking things of Chinese fashioning, which I imagine it would have been a great trial to the nerves to hear played upon—and yet in all the after years that I lived in the house I never

heard a note of music. It had no home there. Our
neighbours in the next house, however, were abounding
in it, and often in the summer evenings, when the win-
dows would be thrown wide open, the fine baritone of
Theo Marzials,[42] who was frequently there, would come
floating into our front rooms. Rossetti had a great ad-
miration for Marzials as a poet, and often spoke of the
high quality of his poems and songs, which were then
becoming very popular and much discussed. But for
music itself he did not care a whit, and was very much of
the opinion of Dr. Johnson, who, when once he was
asked if he liked music, replied that perhaps of all noises
it was the most bearable !

In relation to this indifference to music shewn by
Rossetti, I recollect in the course of one of our conversa-
tions whilst working together, something led to his giving
me an idea of what he thought of Handel's *Messiah*,
which was at the time being performed at one of the
Crystal Palace festivals. Once, he said, he had been
induced by a friend to listen to it, and it seemed to him
that everybody got up and shouted at him as loudly as
possible ! Another time, Mr. Leyland[43] took him to the
Royal Opera House to hear *Fidelio*. The next morning
I was curious to know what he had to say in regard to
such a masterpiece, but he could not give me a clear idea
of what it was all about. The only notion he had of it
was that of a man who was taken out of prison, where
he had been for a couple of days without food, and who,

when a loaf of bread was given to him, instead of eating it like any starving man would do, burst out into a long solo over it lasting for ten minutes—which he thought was obviously absurd!

But the musical instruments were only a few of the many odds and ends of all sorts that were stacked away wherever a place could be found for them. Anything Rossetti saw in his rambles that might be of possible use to him for a picture he would buy. He delighted to take an evening's walk through Leicester Square, visiting the various curiosity shops in that neighbourhood, or through Hammersmith, a district where many a Chippendale chair or table could be met with and bought for next to nothing, such things not being then in the repute that they have become since the taste for Queen Anne houses and fittings sprang up.[44]

On returning to the studio, we found there Howell, who had dropped in, and now the flow of talk became lively. Howell had a lot to say, and it consisted of the most astounding experiences and adventures he had gone through. He had just left Whistler, and was full of a "long Eliza" he had picked up somewhere, of his etching of old Battersea Bridge,[45] of which he had been shown a proof, and of his latest witticism.[46] The main object, however, of Howell's visit was to get from Rossetti a drawing he had made of a lady. I infer some bargaining had been going on between them, and that the drawing formed part of the bargain, but as Rossetti prized it

highly, to gain possession of it was not a very easy matter and required much diplomacy.

I now had an opportunity of looking over and admiring a series of Rossetti's first ideas and sketches for many of his pictures, and studies of heads, which were contained in a large, thick book, lying on a little cabinet in a distant corner. It was a great and unexpected treat to see this collection, a most varied one, amongst which were many carefully finished likenesses, some in red chalk, and others in pencil and in pen and ink, including pencil sketches of John Ruskin [47] (not bearded then), Robert Browning,[48] Algernon Charles Swinburne,[49] William Morris,[50] and other well-known men.

At last we came to the page at which the drawing Howell had come to secure was affixed. It was a beautiful face, delicately drawn, and shaded in pencil, with a background of pale gold. Howell, with an adroitness which was remarkable, shifted it from the book into his own pocket, and neither I nor Rossetti ever saw it again.

As we turned over the contents of this volume, a small, hasty, but exceedingly realistic pen and ink sketch, that had nearly got passed over, arrested my attention. It was of Tennyson,[51] seated and reading out his poem *Maud.* This reading took place in Browning's London residence, in the presence of Browning, Mrs. Browning, Rossetti, and his brother.[52] Whoever possesses the little sketch ought to prize it very highly.[53]

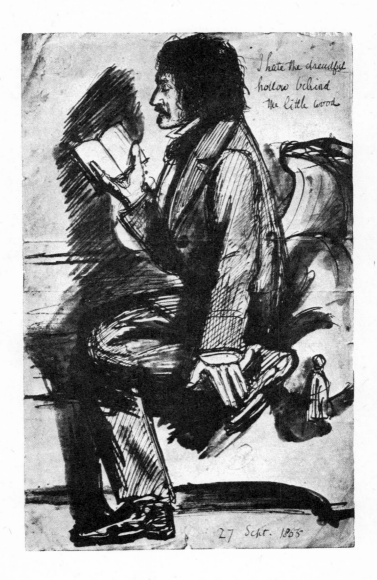

I hate the dreadful hollow behind the little wood

27 Sept. 1863

The pages of the book were still being turned over, slowly, by reason of the accompanying flow of lively recollections and stories of this or that individual whose face formed the subject of a sketch. The book was a rich record of past days and memories. And many a tender little sketch of his late wife was to be found there, with the same sad, beautiful weary expression that had struck me so much in his *Beata Beatrix*.[54]

Chapter IV.

Morris, Marshall, Faulkner, & Co.—Edward Burne Jones—" St. George and the Dragon"—" Parable of the Vineyard"—Ernest Gambart—The Llandaff triptych—" Girlhood of Mary Virgin"—Rossetti's bed and bed-room—The " Germ"—" Poems"—James Collinson—Walter Howell Deverell.

Rossetti was now, at this period, in the prime and fullness of his mental powers. He was in that happy state when all that he painted was eagerly sought after. The abundance of his work in the years previous to my meeting him shewed ample proof, both in pen and pencil, that those years had been busy ones. And although as yet his poems were only known to a few of his friends, he had written enough to justify him in publishing a volume which, but for a strange romance in his life, would have appeared long ere it did.[55]

It was now that the association[56] started by William Morris, having its home in Queen Square, Bloomsbury, and for its object, it is said, the education of the upper classes in the knowledge and right discernment of the really beautiful in Art, began to bring forth fruit. Its work-contributing members were Morris, Rossetti, Ford Madox Brown, Edward Burne-Jones,[57] and one or two others, with Morris as manager and controller. For this

firm Rossetti made numerous designs for their stained glass department, and what always struck me in these conceptions of his was, that they worked up as finely into pictures as stained glass which, as far as my observation goes, is rarely the case in the majority of glass designers' inventions. For instance, his series of six illustrations for the story of *St. George and the Dragon*,[58] and the very fine way in which he has treated the *Parable of the Vineyard*,[59] rendered it unnecessary to make any alterations in them when some years later they were turned into important pictures.[60]

In both series of designs—for *St. George and the Dragon* and the *Parable of the Vineyard*—Rossetti made great use of his friends, and introduced their heads freely into his conceptions.[61] In one of the compartments of the *Parable* he has William Morris, who is generally the strong, wicked man of the lot, concealed by a door, in the act of dropping a big stone on the head of the Lord of the Vineyard's collector who has called for the vintage dues.[62] In the last of the set he re-appears in a very dejected state, and in the company of the rest of the bad husbandmen,[63] amongst whom are to be seen Algernon Charles Swinburne and Ernest Gambart,[64] the then great picture dealer, all wobegone and roped together, on their way to receive condign punishment. Edward Burne-Jones, by reason of his gentle disposition and refined face, was the " good boy " of Rossetti's designs. Howell figures twice in the *Saint*

George and the Dragon story—first, as St. George himself in the act of slaying the monster, and next in the final scene, where he enters triumphantly into the city with the Princess, as her deliverer, the dragon's head being borne in front of the procession as a trophy of his prowess. The cartoons of this romance were framed and used to hang from the staircase wall, but three of them having been removed and turned into water-colours—*The Casting Lots for the Victim, The Slaying of the Dragon,* and the *Triumphant Entry*—the rest were taken down and given away or lost.

Sketches for the wings of the altar piece of Llandaff Cathedral were also noticeable works. The subjects were David as shepherd for the one, and David as Psalmist and King, for the other. Rossetti always spoke very slightingly of this triptych to me, and considered it as a work that he would rather not discuss. But it surprised me by its originality and breadth of treatment when it made its appearance after his death in the exhibition of his collected works held at Burlington House. In execution it was by no means so weak as he had always led me to believe.[65]

Passing through a dark part of a back hall, my foot caught the corner of a picture stacked with others against the wall. I picked it up and found it to be a photograph. Seeing me looking at this, Rossetti told me it was taken from the first picture he had ever painted in oils, which was exhibited in the Hyde Park Gallery, instituted by

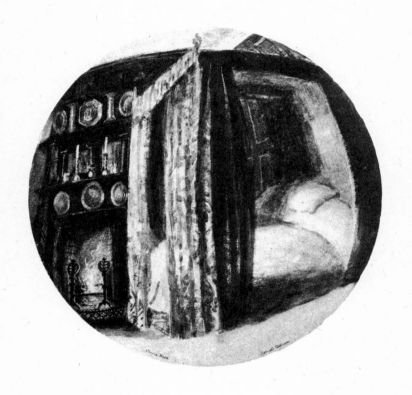

the little band of the Præraphaelite Brotherhood in 1849,[66] when he was about twenty years of age. The subject was "Mary the Virgin," who is represented seated, and embroidering a white lily upon a piece of dark-coloured cloth or silk, under the guidance of S. Elizabeth. In the foreground is a lily, growing from a vase, which she is evidently copying, whilst a child angel is employed in watering it.[67] I learnt from Rossetti, that it was to a great extent painted under the instruction of Ford Madox Brown, from whom he had gained much of his knowledge in the practice of oil painting, and who had contributed to the same exhibition a work of his own, the subject being taken from *King Lear*.[68]

Howell, who had joined us, wanted to show me a bit of old oak carving in Rossetti's bedroom, and, as the door was open, we went in. I thought it a most unhealthy place to sleep in. Thick curtains, heavy with crewel work in 17th century designs of fruit and flowers (which he had bought out of an old furnishing shop somewhere in the slums of Lambeth), hung closely drawn round an antiquated four-post bedstead.[69] A massive panelled oak mantelpiece reached from the floor to the ceiling, fitted up with numerous shelves and cupboard-like recesses, all filled with a medley of brass *repoussé* dishes, blue china vases filled with peacock feathers, oddly-fashioned early English and foreign candlesticks, Chinese monstrosities in bronze, and various other curiosities, the whole surmounted by an ebony and ivory

crucifix. The only modern thing I could see anywhere
in the room was a Bryant and May's match box ! On
the other side of the bed was an old Italian inlaid chest
of drawers, which supported a large Venetian mirror
in a deeply-carved oak frame. Two or three very un-
inviting chairs, that were said to have belonged to
Chang the Giant—and their dimensions seemed to
warrant that statement, as they took up a considerable
amount of space—and an old-fashioned sofa, with three
little panels let into the back, whereon Rossetti had
painted the figures of Amor, Amans, and Amata, com-
pleted the furniture of the room. With its rich, dark
green velvet seats and luxurious pillows, this sofa looked
very pretty and formed the only comfortable piece of
furniture visible.

The deeply-recessed windows, that ought to have
been thrown open as much as possible to the fresh air
and cheerful garden outlook, were shrouded with curtains
of heavy and sumptuously-patterned Genoese velvet.
On this fine summer's day, light was almost excluded
from the room. The gloom of the place made one feel
quite depressed and sad. Even the little avenue of lime-
trees outside the windows helped to reduce the light, and
threw a sickly green over everything in the apartment.
It was no wonder poor Rossetti suffered so much from
insomnia !

A few pictures, not of a very cheerful description,
hung on the walls where there was space. One, I re-

member, was particularly gruesome. It represented a woman all forlorn in an oar-and-rudderless boat, with its sail flapping in the wind about her, alone on a wide expanse of water. In the distance was a city in flames, over which the artist had inscribed *The City of Destruction*, in the sky were numerous winged dragons and demons, whilst swarming around were horrible sea monsters, all intent upon upsetting the boat. It was not a bad picture as far as finish and colour went, but the subject was too dreadful.

On returning to the studio we found Rossetti engaged over some letters. Four little magazines called the *Germ*[10] were lying on the table, and these I looked over with much interest. The *Germ* was a collection of prose and poetry published monthly, with an etching in each number contributed by one of the members of the brotherhood. Only four numbers made their appearance, the receipts arising from their sale not being sufficient to cover the cost of production. Rossetti contributed the poems the *Blessed Damozel*, and *My Sister's Sleep*, and a romance entitled *Hand and Soul*.[11] *My Sister's Sleep*[12] was afterwards included in his volume of *Poems and Ballads*[13] that came out some time after. The etchings were by Holman Hunt, Ford Madox Brown, James Collinson,[14] and Walter Howell Deverell.[15]

Chapter V.

An hour or two of daylight yet remained, and so we
sallied out into the garden to see Rossetti's pets, or his
animals rather, as it would be wrong to describe them as
pets. Experience of Rossetti, and close intercourse with
him, led me to the conclusion that the Poet-painter had
not any great love for animals, nor knew much about their
habits. It was simply a passion he had for collecting,
just as he had for books, pictures and china, which im-
pelled him to convert his house into a sort of miniature
South Kensington Museum and Zoo combined.

His collection of queer, outlandish creatures was
mostly kept in a series of wire-woven, outhouse compart-
ments, located in one portion of the garden. In one of
them I noticed a large packing-case covered over by a
heavy slab of Sicilian marble. My curiosity led me to
enquire of Rossetti what it contained, when he told me
there was a racoon inside. On hearing that I had never
seen such a creature, he asked me to help him remove
the stone, and then, to my astonishment, he put his hand

in quickly, seized the "coon" by the scruff of its neck, hauled it out, and held it up, in a plunging, kicking, teeth-showing state for me to look at, remarking— "Does it not look like a devil?" to which I agreed. It seemed to me a most dangerous creature to tackle, and I would not have held it as he did upon any consideration.

This beast gave a world of trouble and annoyance by constantly escaping. At one time it suddenly disappeared, and no one knew what had become of it until there came a letter from a lady, who lived some doors away, containing a bill for eggs destroyed by the "coon," which had made its way regularly down a chimney into her henroost! With some difficulty it was captured, and once more put back into what appeared safe keeping, but ere a few weeks had elapsed it was out again on the warpath. This time no trace could be found of it, until the necessity arose of looking up a lot of Rossetti's manuscript poetry, lying in the bottom drawer of the massive Elizabethan wardrobe, when, to my surprise, I found the manuscript gnawed into little bits! The "coon" had been hiding there all the while, prowling about the house at night in search of food. This accounted for certain mysterious noises which had occurred in the dark hours of the night—sounds, as it were, of a faint, flat footfall up and down the stairs, which to the housekeeper, who had just lost her husband and was in a chronically hysterical state, seemed to be that of his ghost! Eventually

the troublesome creature had to be sent back to Jamrach, the great animal importer of Liverpool, from whom it was purchased originally.

There were two other curiosities—a pair of armadillos which, under the idea that they were harmless, had the run of the garden. They, too, seemed to have caught the contagion for mischief. Now and then our neighbour's garden would be found to have large heaps of earth thrown up, and some of his choicest plants lying waste over the beds. This was the work of the armadillos. As in the racoon escapades, letters of complaint were received, and so baits were laid for the pests in the form of bits of beef saturated with prussic acid. The beef disappeared, and so, it was hoped, had the armadillos; but no—after about three months they reappeared in a sadly mangy and out-at-elbows state; they had evidently shed their scales during their absence, and new ones were forming. I suppose that after taking the dose of poison, feeling the worse for it, they must have betaken themselves to a hospital, and were just discharged as convalescent. Very soon after their return, I am sorry to say they slid back into their old mischievous habits, and at last had to be made over to the Zoological Gardens, where no doubt they were better guarded.

Amongst this curious collection of odd animals were a couple of kangaroos—mother and son. As far as my observation went, I do not think they lived on very good terms with each other. At any rate, the mother was

found dead one morning, murdered by her bloodthirsty son. There must have been an unusually fierce quarrel over family matters in the night, with this as a consequence. Nemesis, however, overtook the wicked son, for he also was found dead in his cage some few days after, but whether he committed suicide through remorse, or whether the racoon, who was strongly suspected, polished him off, was an open verdict.

When I first became acquainted with Rossetti, he had a peacock, a troublesome creature, which gave great annoyance to the neighbours by its continual shrill trumpetings. The complaints received were so numerous that the bird had to be got rid of, and a clause was introduced into the leases of Lord Cadogan's property, that no peacocks should be kept in the gardens of his tenants!

Before these complaints were made, a fallow deer was added to the collection—a graceful, beautiful creature, which, from its first introduction to the garden evinced the greatest curiosity in regard to the peacock. Perhaps it was the feeling of surprise experienced by the animal at the peacock continually displaying its gorgeous tail, which induced it to follow the bird up and down the garden, and eventually to stamp out every feather the tail of the poor thing possessed.

Amongst the indoor pets was a singularly wicked and morose parrot. Its sole delight seemed to be to get visitors to stroke its head, and then, without any warning, suddenly to fasten upon their fingers and finish up with a

sly, low chuckle. Now and then the parrot would utter quite *apropos* sentences in the most unexpected manner. One Sunday morning, I recollect, Rossetti was sitting in his lounge chair, and warming his feet. The bells from the neighbouring church of S. Luke were in full swing. For some time the parrot had been unusually silent, when all of a sudden it broke the silence with the exclamation, " You ought to be in church now ! " It is possible the servants had taught it this speech, but, at any rate, it gave Rossetti great amusement, and he was never tired of relating the story to his friends.

Chapter VI.

BETWEEN Rossetti and Howell there existed a friendly
rivalry as to who could display the finest show of old
Nankin. Howell, perhaps, possessed the greatest facility
of the two for picking up china *bric-a-brac*—or anything
that was worth buying—from the fact that his time was
generally spent in ferreting out all the old shops in the
most likely neighbourhoods, as well as in the various sale
rooms which he was always frequenting. He had, more-
over, a keen eye for what was good, together with an
unrivalled amount of assurance, that assisted him wonder-
fully in all his bargains with dealers, who were wont to
get the advantage of customers less acute.

On one occasion, Howell's rambles took him to
some out-of-the-way and unfrequented part of Hammer-
smith, which at that time abounded in small furniture-
dealers' shops. Often, some very valuable thing might
have been purchased there for a few shillings, that at
present could not be procured for pounds. In one of
these old furniture shops, Howell, with hawk-like eye,

espied the corner of a blue dish peeping out from a pile
of miscellaneous odds and ends in the window. It was
not so much the shape of this visible portion of crockery
but the colour, that attracted him; it was the blue, the
sweet, rich blue, only to be found in the choicest Nankin.
He entered the shop, and began prying about, asking the
price of first this thing and then that in the window
until at length, as though by an accident, the whole of
the dish that had lain almost hidden was exposed to view.
O heavens! What a thrill of delight passed through
his soul when it was pulled out for inspection. It was a
veritable piece of Imperial ware, and a fine specimen,
too! His mind was made up. Have it he must; but,
not to appear too anxious to get possession of it, he com-
menced by buying one or two things he did not want
rather above their value, and then, by artful cozening,
got the dish thrown in as a final make-weight to his other
purchases for next to nothing. His afternoon's work
was done; he had secured a prize which would fill Dante
Gabriel's soul with envy when he saw it. A cab was
called, and away he drove home, chuckling with delight
to himself over his acquisition.

That evening was spent in arranging the menu of a
choice little dinner, which was to be given in order to
display his treasure, and in selecting the names of those
of his friends who should be chosen to see the dish. Invi-
tations were written and duly sent. Dear Gabriel's name,
of course, was first on the list; then that of Whistler—

better known amongst his friends as " Jimmy "—as he was one of the triumvirate of Chinese worshippers; then came the Ionides Brothers,[76] Leonard R. Valpy,[77] George Howard,[78] George Price Boyce,[79] Burne-Jones, Morris, old George Cruikshank,[80] John William Inchbold,[81] and several others who were habitués of the house.

As it had got about that Howell had something to show that would knock them all into fits, there were no absentees. The table was set, and the guests had all arrived, brought thither not only by the prospect of spending a pleasant evening, but also by curiosity to see what Howell had to exhibit. When the substantial part of the feast came to a full end, Howell felt his guests were in a sufficiently appreciative state of mind, and so the dish, for the advent of which each one of the party had been on the tip-toe of expectation, was at length produced, Howell himself bringing it in, carefully wiping it with a silk handkerchief. There was a concentrated " Oh ! " from all assembled at the table, which, having been partially cleared, had space enough to allow the dish to be placed in its centre, that all could view and admire it. And it bore the closest inspection, for it was certainly as good a piece of Nankin as could be found in the best of a lucky day's hunt. Rossetti waxed enthusiastic over it; he turned it round, and examined it from every point of view, and not a flaw could he find, nor the ghost of a crack, or a suspicion of an inequality of colour in it. Everyone congratulated Howell on his

being the possessor of such a beautiful specimen of " Blue." After it had been admired and breathed upon, coveted and delighted in, fondled and gushed over, hustled and almost fought for—in short, after having created as much squabbling and controversy as, once upon a time, the partition of Poland did among the Powers, the dish was tenderly removed by its owner, and carefully deposited in its shrine on a cabinet in an adjoining room.

As there were ladies present, a little music was indulged in, but as a rule Howell's parties were chiefly composed of people who were not very musically inclined. As in Rossetti's house, the place abounded in musical instruments, but never a one that could be played upon; all were of antiquated construction, only to be looked at, and talked about in a hushed whisper of admiration for their workmanship and adornments. It was now getting well on towards midnight, and most of the party began to think of getting home—Howell's Fulham villa was not a very easy place to get at, and after twelve o'clock it was only by chance a cab could be found. Whilst the ladies of the party were upstairs wrapping themselves up for their journey, and the men were downstairs occupied with their hats and overcoats, Rossetti was hanging about the hall in a thoughtful kind of way. He had on the Inverness cape which he generally wore at night, and I saw him go into the room where the dish was deposited, to have, as I thought, a last look at the treasure, but—shall I tell it?—he hastily dislodged that

dish by stealth, concealed it beneath the cape of his cloak and carefully wrapped its ample folds around it, that none could perceive what he carried under his arm. Having so done, he took leave of Howell and his wife in the most charmingly innocent manner possible.

We walked towards Cheyne Walk together, but on the road Rossetti hailed a cab that happened to be in view, and the rest of the distance was soon got over. On our arrival at his door, having dismissed the cabman, he let himself in, and pulling out the dish from under his cape had a good look at it by the gaslight in the hall, chuckling the while with glee, for in his mind's eye he saw the long face Howell would pull on discovering his loss. He cautioned me not to let him know anything which would give him a clue as to the disappearance of the dish, or its place of concealment. Then, finding his way to the back hall, he proceeded to carefully hide it in the recesses of the massive oak wardrobe that stood there, and the more effectually to conceal it, swathed it round and round with model's dresses and other artistic draperies for the custody of which the wardrobe was employed. Having done all this to his satisfaction, Rossetti took his candle and went to bed.

Next morning, when he made his appearance at the breakfast table, we had our usual chat respecting the day's work, and whatever else required to be discussed. In the course of our conversation, Rossetti said, suddenly,

"Dunn, I shall give a return party to that of

Howell's last night. This is Tuesday: I'll ask him for Friday, and tell him he must come as I have picked up a piece of ' Blue ' that I think will rival his."

Accordingly, he wrote him a note to that effect, and also dispatched invitations to most of those who were present at Howell's party, and to a good many more, making altogether enough to fill the dining table, which was able to accommodate at least twenty.

On the afternoon of the day of the dinner, Howell called in a cab, bringing his factotum with him, a useful fellow by whom he was generally accompanied in his expeditions. He left his man waiting in the cab, and on gaining admission to the house, and hearing that Rossetti was in the studio, he went in and found us both there. After an inordinately long confabulation over everything that could be talked about, but without a word concerning the dish, Howell, by and bye, went from the room upon some pretext or other and left Rossetti busily painting away. As I afterwards learnt, Howell guessed pretty shrewdly who had his dish, and where it was to be found. Instinct took him to the old wardrobe; softly opening its massive doors, he peeped in, then searching about with his hands, felt his precious dish underneath the pile of draperies that Rossetti had heaped over it. To remove these and disentangle his property was the work of a few seconds; recovering his prize, he softly stole away along the back hall, round to the front door, which he opened, and went out to his man who was waiting his instruc-

tions. To him he handed the dish through the window, receiving in return another of the same size and shape. Howell went back, and after putting this dish into the wardrobe in the place of the other, re-entered the studio, and with the accompaniment of Irish cold and the indispensable cigarette, resumed the conversation for another hour or so. When he could find nothing more to talk about, he took his leave in order to dress for the dinner. Rossetti was strangely unsuspicious of Howell's movements; I suppose he thought the hiding place he had fixed upon was so secure, that it never occurred to him to go and see what Howell had been up to and whether the dish was still there.

At the appointed hour, our guests came flocking in until the whole of them had arrived. When they were assembled in the dining-room, and had taken their seats around the table they formed a goodly company. The dinner was well served, a professional cook having been engaged to prepare it, and a distinct success; the wine was excellent and the conversation sparkling. At last, Howell managed to divert the talk to the subject of Blue china, and the dish of his that had excited so much admiration on the night of his party, whereupon Rossetti declared he had something just as fine. Howell challenged him to produce it, so off went Rossetti to the wardrobe most confidently: he fished out the dish and brought it away swathed in drapery, just as he supposed he had left it. In a few minutes he returned to the

dining-room with the package, and began to carefully re-move the wrappings. As the dish became uncovered, a curious, puzzled expression came over his face, and when it was entirely exposed to view, he stood still in blank astonishment. For a few moments he was silent; then his pent-up feelings burst out in a wild cry.

"Confound it! See what the spirits have done!"[88]

Everyone rose to look at the dish. A dish it was, certainly, but what a dish! Instead of the beautiful piece of Nankin that was expected, there was only an old Delft thing, cracked, chipped, and discoloured through the numerous bakings it had undergone. The whole party, with the exception of Howell, who looked as grave as a judge, burst into a roar of laughter. Rossetti soon recovered himself and laughed as heartily as any of his guests at Howell's ingenious revenge.

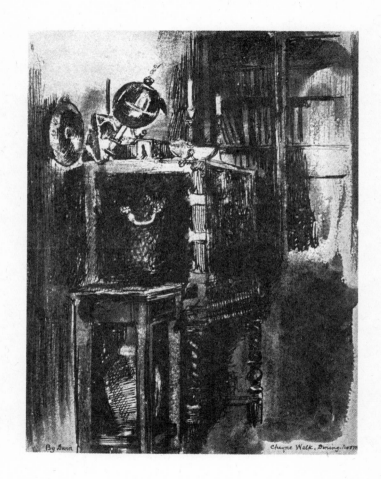

By Dunn Cheyne Walk, Dining-room

Chapter VII.

ROSSETTI'S greatest pleasure was to gather around him those whom he liked, and his little social dinners, when they took place, were events to be remembered.[83] When the party was an exceptional one—I mean as regards the number of friends invited—the table was laid in the so-called drawing-room, an apartment comprising the entire width of the house and boasting of five windows, which afforded an extensive and interesting view of Chelsea Reach and its picturesque old wooden bridge. It was a beautiful room by day, when the sun streamed in and lit up the curious collection of Indian cabinets, couches, old Nankin, and the miscellaneous odds and ends with which it was crowded almost to the point of superfluity; and at night, when the heavy Utrecht velvet curtains were drawn and the dining table was extended to its utmost limits, when the huge Flemish, brass-wrought candelabra with its two dozen wax lights, that hung suspended from the ceiling midway over the table, was lit up, and the central, old-fashioned epergne was filled with flowers, the room was filled with a pleasant warmth and glow anticipatory of the company expected.

On such occasions, Rossetti would relinquish his poetry or painting, and devote half-an-hour or so to allotting to his guests the several places that they were to occupy.

"Dunn," he would say to me, "we'll have Howell here; so-and-so is slow and he shall sit next to him; he'll be sure to be amused and wake up when that droll fellow begins pouring out his Niagara of lies. And here," he would add, "Sandys[84] shall have his place, just opposite, so that whatever Howell relates, Fred shall have a chance of capping his romances with some more racy." And thus with each guest; all were placed as he considered would be most conducive to the harmony of the evening. And so happily did Rossetti arrange matters, that his dinners never failed to be indeed festivals of exuberant hilarity. Christopher North's *Noctes Ambrosianæ* might have equalled, but certainly did not surpass them, for wit and humour danced rampant up and down the table. At such times, would be present Burne-Jones, George Augustus Sala,[85] Westland Marston,[86] Ford Madox Brown, Morris, and other well-known men.

But it was not really until the feast was over, and an adjournment to the studio came about, that the night's enjoyment commenced. If the conversation took a turn to suit Rossetti's humour, he was pretty sure to be first and foremost in the fun.[87] Howell was the greatest romancer of all the Rossetti circle, and he had always some monstrous story to tell about anybody who happened

to be enjoying notoriety at the time, with whom he would claim to have a perfect intimacy. Rossetti had a keen relish for these yarns, and would roll back in his chair with delight at Howell's latest adventures, the relation of which used to proceed in the most plausible and convincing manner possible. Fred Sandys was also a splendid raconteur, and these two men between them would keep us all listening and set us all laughing until long past midnight.

Smoking was indulged in by most of Rossetti's friends, although he, to his frequent regret, could never venture to touch either pipe, cigar, or cigarette. William Michael Rossetti, however, made up for his brother's inability on this score. Swinburne was also a non-smoker. I do not think I ever saw him attempt even a cigarette. Howell was never without one; from morn till night he smoked, and the amount of cigarette ends he threw away in a day might well have made a good ounce weight of tobacco.

During the period in which these convivialities were rife, the Tichborne trial[88] formed the all-absorbing topic of the day, and though Rossetti as a rule carefully avoided reading the newspapers, he nevertheless took a keen interest in the claimant, and followed the record of the case closely from day to day; that the claimant was an impostor, I believe was his conviction at an early stage of the proceedings. It was upon one of these evenings, when the conversation respecting the great case had set

in, and the opinions of those present as to the rights and wrongs of it fizzed about as confusedly as squibs on a Guy Fawkes night, that Rossetti propounded a highly original solution of the question.

"Let," he said, very gravely, "the carcass of an ox be taken into the court, and let the claimant be brought forward and told that he must cut that ox up in the presence of the judge and jury. It would be seen at a glance," he maintained, "whether that man had ever been a butcher; unconsciously he would hold the knife in a way no tyro could, and unconsciously he would set to the task of cutting up the carcass and betray himself at every slash he made."

Such was Rossetti's idea. It was an ingenious one, but whether reliable or not was a matter of opinion, and led to a protracted discussion in which nobody was convinced.

Chapter VIII.

Rossetti and Spiritualism and Mesmerism—Some mediums—Daniel Home—Bergheim—The Master of Lindsay—Theodore Watts-Dunton—A mesmeric entertainment.

IT was about the first year or so of my intimacy with Rossetti that table-turning, spirit-rapping, planchettes, and spiritualism under its many phases had taken hold of society, and provided the trifles of the day. Whether Rossetti had any real belief in spiritualism, or whether he wanted to persuade himself that he had, I can hardly say. He was of a highly imaginative nature, and everything that appertained to the mystic had a strange fascination for him. In spiritualism he took an interest for some time; he went to all the private séances to which he happened to be invited, and now and again would give me an account of some of them, when such well-known mediums as Mrs. Guppy,[89] Mrs. Fawcett,[90] and Daniel Home,[91] and others were present.

The result of witnessing the performances of these professionals was that Rossetti thought that he, too, would have little séances at home, and from time to time Whistler, Bell Scott, and a few other friends would meet together at Cheyne Walk to have their own experiences

of the matter. On these occasions the spirit-rapping and gyrations of tables would be carried on until the uncanny hour of midnight. As each of the experimenters was suspicious of his neighbour's honesty when the table became rampant, the results were mostly unsatisfactory. At one or two of these meetings, I remember, some remarkahle messages were received from the spirits, which could not be accounted for.

Mesmerism Rossetti had a reasonable faith in. He was in a great measure led to this belief from having met one night, at a friend's house, a Mr. Bergheim,[92] who possessed extraordinary powers in this direction. So impressed was he with what he had seen on this occasion that he asked him to come one evening to Cheyne Walk to give a proof of his mesmeric powers to a few friends he intended to invite to meet him, and who would be interested in Bergheim's experiments. Amongst the party were Morris, the Master of Lindsay,[93] Leyland, Sala, and Theodore Watts-Dunton.[94] Watts-Dunton used to be Rossetti's confidant of much that he did not speak of to his general friends.

The entertainment in question was held in a lordly pleasure marquee, which Rossetti had caused to be erected in the spacious garden at the rear of the house. This tent was furnished in a very luxurious manner: couches, comfortable chairs, many-countried cabinets, Persian rugs, and such flowers as were in bloom were dispersed profusely within, and gave it a delightful Eastern appearance.

When all the party were assembled, conversation
upon the occult became general. After awhile, the
Master of Lindsay related a wondrous story: that some
time previously he was with Home the spiritualist—whose
name was then on everybody's tongue—and saw him,
whilst in a mesmerised state, rise from off the floor and
ascend to the ceiling of the apartment he was in, which
was a very lofty one, sufficiently lofty, indeed, to enable
the narrator to catch hold of Home's foot as he rose above
his head, and to find that in spite of all endeavour to
keep him down he still ascended, leaving his shoe in his
hand. And also that, on another occasion, he had seen
him float out of one of the windows of the room they
occupied into the open air, and re-appear a few minutes
afterwards floating through the next. This was related
by the Master of Lindsay in such perfect belief and sim-
plicity, that we could but listen and, wondering, accept
his assertions accordingly.

Of course, Howell had something equally wonderful
to tell, and, as far as I recollect, it was in connection
with Richard Burton,[95] the traveller and orientalist, with
whom he professed to have gone through supernatural
experiences of a most astounding nature. Then arose
and spoke Sala. He had just come up from the Broad-
moor criminal lunatic asylum, and he gave us a most
interesting account of some of the inmates confined there
for murder. He had seen Constance Kent.[96] Usually
she was very quiet and reserved, but she had recurrent

fits of madness that came on with the full moon. Then her depravity would break out and find vent in the most violent actions and Billingsgate language, so that it was only with the greatest difficulty she could be managed. It was on one of these occasions he had seen her. Edward Oxford,[97] who shot at the Queen some years ago, he also mentioned as having seen. There was nothing remarkable about him in any way. He was very quiet, and employed in doing portions of the rough painting-work that was required in the establishment. Another and much more interesting criminal was the artist, Richard Dadd,[98] who was detained there for murdering his father on Blackheath Common many years ago. A terrible idea had weaved itself into his disordered brain— that it was his mission to kill the devil! And that notion, worming itself deeper and deeper into all his thoughts, caused him to wake up one morning with the conviction that his father was the devil. He took him for a walk and slew him. The Broadmoor authorities were allowed to furnish him with paints and brushes, and other necessaries for painting, and much of his time was occupied in making designs of the wildest and most ghastly character. Sala found him at work upon a picture of Job suffering from the plague of boils. The boils were depicted in every stage, and in the most microscopic manner, and he seemed to take a delight in painting them, licking his brush over an extra ulcerous one. There were a good many of his designs, so Sala said,

about the cell he occupied, all painted with extreme finish and photographic minuteness. One especially noticeable was of Richard III., after having slain his two nephews. He was depicted as holding up his sword high aloft, and catching in his mouth the blood drops as they fell. Then, in parenthesis, Sala told us how Dadd, having killed his father, escaped from the scene of his crime and took his guilty flight to Dover, and from thence crossed the Channel with the intention of going to Paris. On his way thither, he still found himself in doubt as to whether, after all, he had accomplished his mission or not. In the compartment of the railway carriage that he had taken a place in, was a fellow-traveller. They entered into a conversation which lasted well-nigh the whole journey. Dadd, still in doubt, began to fancy his companion was the devil incarnate, whom it was his mission to kill. Through the window of the carriage he gazed at the heavens and looked for a sign from it. The sun was setting and the sky full of threatening rain-clouds. It seemed borne in upon him that if the sun sank in serene and unclouded splendour, his fellow-traveller's life must be spared, but if otherwise, he saw his duty and was resolved to do it. The sun sunk below the horizon cloudlessly, and his companion little knew of the fate he had escaped.

These various relations were interrupted by the arrival of the two young women whom Bergheim had arranged should be his mediums for the evening. Hear-

ing that they were on their way to the tent, he mes-
merized them before they appeared, so that they both
entered in a clairvoyant state. Rossetti's surprise at this
was great. Not long after, Bergheim asked him to act
in an improvised little drama that he had thought of.
Rossetti was to be a sailor, and act with the medium
selected as though he were going to join his ship, which
was about to sail on a long-service cruise. So, taking his
cue, he told her a prettily-concocted tale of his being
ordered away that night on Her Majesty's service, which
the girl listened to with the greatest emotion. Another
of the party then came forward, and represented himself
as a naval officer sent by the captain to take him aboard;
the anchor having been weighed, the captain was anxious
to set sail. When this was told her, and she found her
sailor must leave her, she got into a terribly excited state,
and threatened to stab the man who would separate
them. At last, however, she allowed Rossetti to be
taken away, and as soon as he had disappeared through
the tent awning and could no more be seen, she fell to
the ground in a fit of hysterical weeping.

Another of the party, a somewhat heavy man, was
then asked to lie down on the ground, which he did.
The mesmerist directed the medium's attention to him,
scolding her as if she were a careless nursemaid in charge
of a small child, and telling her that there was a carriage
and a pair of runaway horses galloping down a supposed
lane, and that unless she could rescue the child in time it

would inevitably be run over and killed. In a terrible fright, she ran to the supposititious child, picked him up and carried him away to a safe place with all the ease that a grown-up young woman would a child of three or four years of age.

There were many other scenes of a similar kind enacted, until Bergheim thought his mediums were exhausted. When he restored them to their usual condition, by a few passes and a smart tap on the shoulder, I asked one of them if she knew what she had been doing, but she seemed quite unconscious of what had taken place, save that she thought sleep had overcome her, in which she dreamt something too indistinct to remember. I witnessed all these things, and to me they appeared quite unaccountable. If the two girls brought hither by Bergheim were in collusion with him, why they must have been equal to the best actresses that ever trod the stage. Even granting that they were acting their parts, I cannot make out how the medium who lifted up one of us off the ground could have got her strength, for it was done without any undue exertion, and she was but an ordinary type of a little London milliner.

Chapter IX.

In recalling the foregoing scenes, I have many times asked myself why I should relate them, and whether such things were not too trivial to set down in writing? And my answer to myself was always, that the interest displayed by Rossetti towards everything bearing on the occult gave an insight to his nature, and however inconsequential these incidents may appear, they show how largely both his poetry and his painting were influenced by the bent of his mind in that direction, and his yearning for the unseen. He would often talk about spiritualism for hours, and many were the curious experiences of ours which we revealed to each other. And, as in a disconnected dream, the conversation would sometimes wander into paths not thought of before, and hence these relations occasionally had their uses.

I recollect on one occasion I had just come from visiting a neighbour—a lady who possessed the original dreaming stone of Dr. Dee[99] which she allowed me to

look at. It was a small, unpretentious bit of crystal, but having such a reputation as it had, I felt as though I too must have a look into it. Full half-an-hour I spent in gazing into it, but I saw nothing. Perhaps the time was not long enough, or perhaps I was not in tune; during the afternoon, however, I learnt that my hostess had seen much and written much more from the pages of antiquated lore that it had unfolded to her—Hebrew, Sanscrit, and heaven only knows what else had been opened up to her enlightened vision.

Full of all this mysterious discourse, I went back to Rossetti and told him all. He listened to my narration with the greatest interest. I spoke of the dreaming stone as the magic " Beryl."

" What did you call it ? " he asked.

I repeated its name—the " Beryl."

" Good," he responded, " that is the very word I want for the title of my poem; it never occurred to me before. I shall now use it; it is better than crystal in every way; it is more rhythmical, and has a greater seeming of mysticism in its sound. Moreover, it is one of the mystic stones named in *Revelations*."

So from that time he substituted the word "Beryl" for "crystal," and built up a wondrous poem with a sonorous title.[100]

Swinburne was a frequent visitor at Cheyne Walk, and I remember well his calling one evening when Rossetti was absent on some china-collecting expedition.

It had been a very sultry day, and with the advancing twilight, heavy thunder-clouds were rolling up. The door opened and Swinburne entered. He appeared in an abstracted state, and for a few minutes sat silent. Soon, something I had said anent his last poem set his thoughts loose. Like the storm that had just broken, so he began in low tones to utter lines of poetry. As the storm increased, he got more and more excited and carried away by the impulse of his thoughts, bursting into a torrent of splendid verse that seemed like some grand air with the distant peals of thunder as an intermittent accompaniment. And still the storm waxed more violent, and the vivid flashes of lightning became more frequent. But Swinburne seemed unconscious of it all, and whilst he paced up and down the room, pouring out bursts of passionate declamation, faint electric sparks played round the wavy masses of his luxuriant hair. I lay on the sofa in a corner of the studio and listened in wonder and with a curious awe, for it appeared to me as though the very figures in the pictures that were on the easels standing about the room were conscious of and sympathized with the poet and his outpourings. The *Proserpine*[101] gazed out more mournfully than I had been wont to see her gaze; her longing to return to earth seemed to have Swinburne as an additional reason for it. On the other side looked out through her frame the *Blessed Damozel*,[102] and " from the golden bar of heaven " *Cassandra*,[103] away in the farthermost part of the studio, peered through the

gloom, as though joining with the others in watching the poet as he impetuously strode up and down the room, each flash of lightning revealing him as one inspired, his wealth of hair giving forth a scintillation of tiny electric sparks which formed, as it were, a faint halo round his head.[104] Amidst the rattle of the thunder he still continued to pour out his thoughts, his voice now sinking low and sad, now waxing louder as the storm listed.

How long his ecstasy would have lasted I know not. I was wondering, when the sounds of a latchkey and the closing of the hall door were heard. In another minute Rossetti entered the studio, boisterously shaking off the raindrops from his Inverness cape, and with a " Hullo! old fellow! " welcomed Swinburne. Divesting himself of his cape, he lit the gas, sat down with his friend, and the night began anew. Their conversation, upon many things, went on hour after hour, until the dawn began to appear, and I arose as one in a dream, and betook myself to bed.

John Trivett Nettleship[105] would sometimes bring his sketches of wondrous, yet hardly worked-out ideas. Those of the Blake-like kind amazed and delighted Rossetti with their audacity of treatment. Nettleship's intense admiration of Browning's poetry and his almost idolatrous worship of the fantastic endeared him to Rossetti: in fact, had he known him a few years earlier, he would surely have found in him a valuable collabora-

teur in the book exhibiting the poetic genius of Blake
that he, in conjunction with Gilchrist, brought out.[106]
Rossetti was greatly interested in Nettleship and all he
did. He regarded him as a genius, and the various
anecdotes which I told him from time to time concern-
ing Nettleship and his peculiarities vastly amused him
and excited his curiosity.

Ted Hughes [107] once showed a little picture to
Rossetti—or he saw it at Hughes' house—entitled
Hushed Music, which delighted him very much. He
spoke to me afterwards about it on several occasions,
remarking that such a work gave fine promise of greater,
and that Hughes would surely make a name for himself.

" Lewis Carroll," [108] the author of *Alice in Won-
derland,* was another frequent visitor at Cheyne Walk
in the early days of Rossetti's occupancy of the house
there. Being an adept in the art of photography, he
took several very good studies there. One of Rossetti,
his mother, and his sister Christina, seated on a little
flight of steps that led to the back hall-door, was es-
pecially happy in the likeness and arrangement of the
family group.

One day Longfellow,[109] who had not long arrived
in London from a tour in Italy, called on Rossetti. He
was a grand-looking man, although somewhat short, with
a fine silver-white beard, and still a goodly amount of
snow-white hair on his head. He had absolutely no
knowledge of painting, and his remarks concerning pic-

tures were not only childish, but indicated an utter indifference to them. Although having just completed his translation of the *Paradiso* portion of Dante's trilogy, he seemed quite at a loss to know what Rossetti's pictures represented.

From the midnight gatherings and conversations that I have mentioned, it will be seen that Rossetti's hours were very late ones. As a matter of course, he was not an early riser, and it was not his wont to commence work much before eleven o'clock in the morning. But when he did, he began right earnestly.

When a design germinated in his brain, it was all thought out and shaped into a pen-and-ink or pencil reality before the subject was transferred to canvas. When the sketch was to his liking, then came the question, What model was best fitted for the subject? And exercising the same fastidiousness as when composing poetry, several drawings of the model's face would be made ere he was satisfied. This accounts for such a number of carefully-finished chalk heads continually cropping up. They are all valuable, because they tend to show the progress and development of his most notable pictures. When all these careful preliminaries had been gone through, the painting would be commenced. But never in a hurry: no attempt was made to partially cover his canvas at once; his invariable rule being to do so much in the time that the model was present as could be well done, and required no alteration the next day.

Alterations, he maintained, meant muddling, and were the death of colour.

All Rossetti's best works glow with rich tones and qualities. In the matter of drawing, however, I am obliged to confess he was not so strong. His curious habit of giving oft-times an unduly long neck to a figure threw him into difficulties in regard to the due proportions of the human body. For his models, he did not rely upon those who were strictly professional. He preferred finding a face for himself, and often a work would be delayed in the execution because the desired face could not be immediately found.

FINIS.

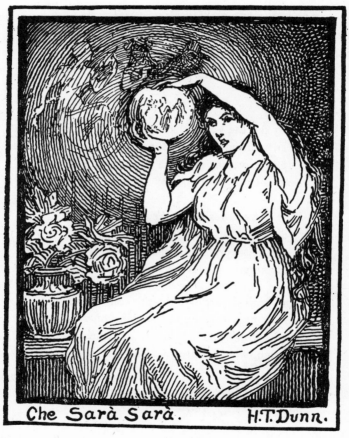

Che Sarà Sarà. H.T.Dunn.

The Crystal Ball, from a design of Henry Treffry Dunn's, by his sister, Edith Hume.

AUTUMN LEAVES.

(Verses for a picture)

Fast fall the leaves, blown by the Autumn blast,
 In swirling heaps on the green sward they lie,
 Sweet memories of the Springtime greenery
And the golden glories of Summer past.

The last red flushes of the sinking sun
 Shed over all a wondrous mystery,
 On toil-worn age nearing eternity,
And the young hearts whose lives are but begun.

And with departing light the conscience grieves
 O'er bygone days, and golden hours misspent
 In selfish deeds and empty merriment,
To find, where fruit should be, but withered leaves.

Henry Treffry Dunn.

February 27, 1891.

NOTES

NOTES.

1. The device is time-honoured; and recently I was amused to see it exercised, by a well-known author, to explain to an obtuse hairdresser the particular fashion in which he desired his hair and beard trimmed.

2. Of Blairgowrie. He fought in the Russian-Turkish War, and was afterwards awarded a medal for bravery. Subsequently he entered the Volunteer Department of the War Office. He died on the 26th July, 1867. His marriage with a sister of the author of these Recollections was to have been solemnized two weeks later, and it may be here mentioned, as an indication of the benevolence of Rossetti's disposition, that when she came to London, for the purpose of seeing her affianced before he was buried, he made her and her mother his guests, in order to well rest themselves between the the two long journeys from Cornwall to London and back.

3. A well-known Art school, situated in Newman Street.

4. Dramatist, author, and painter, 1828—1891.

5. This play was produced at the Lyceum, at which theatre Wills was retained as dramatist, in September, 1872. Although inferior in form to its predecessor, *Medea in Corinth*, which contains his best work, it sprang into high favour with the public, and assisted Henry Irving to confirm the reputation he had previously achieved in *The Bells*. Several plays, of uneven merit, followed from Wills' pen in quick succession.

6. The son of an Englishman and a Portuguese mother, who was born in Portugal towards 1849. He was very intimate with Rossetti and his circle from 1864, but got out of favour with the circle from about 1869. He acted as Ruskin's secretary from *circa* 1865 to 1868, and as Rossetti's selling agent from 1872 to 1876. He possessed a keen artistic perception, and was well versed in all matters pertaining to Art. As these Recollections show, he had also a wit that was as clever as it was inimitable. He died towards 1888.

7. Mr. Seymour Kirkup, an English painter who settled in Florence *circa* 1824, and was ennobled as a Barone of the Italian kingdom. He was particularly known for having, towards 1840, made the discovery referred to. Throughout the greater part of his life he was a fervent spiritualist, and professed to hold intercourse with the spirit of Dante. In a letter to Rossetti, he informed him that the poet had drawn part of his own portrait and written his name under it to oblige him. He died at a great age, about 1880.

8. In the Bargello.

9. Canto xi.:

" In painting Cimabue thought that he
 Should hold the field, now Giotto has the cry,
 So that the other's fame is growing dim.
So has our Guido from the other taken
 The glory of our tongue, and he perchance
 Is born, who from the nest shall chase them both."
 Longfellow's Translation.

10. No. 16, a fine old building, with an extensive garden and a frontage commanding the river, to which Rossetti removed, in the Autumn of 1862, from No. 59, Lincoln's Inn Fields. At No. 14, Chatham Place, Black-friars Bridge (now demolished) he had lived for several years before occupying for a few months the chambers in

Lincoln's Inn Fields. It constituted an eminently congenial residence for him, notwithstanding that the studio was inadequate for his needs. Originally his brother, Mr. William Michael Rossetti, Algernon Charles Swinburne, and George Meredith occupied certain rooms, but, as regards the poet and novelist, not for any great length of time; the first-named continued a partial occupant until 1873. In this house, of which he held a lease, Rossetti was domiciled until his death, although from 1871 he often stayed at Kelmscott Manor House (near Lechlade, Gloucestershire,) of which he and William Morris, the celebrated poet and art designer, were joint tenants. At Kelmscott he was entirely settled from the autumn of 1872 to the summer of 1874, seldom coming to London during that period; but at the end of that time he finally returned to London. A portrait of Mrs. Morris, which Rossetti painted, is now in the National Portrait Gallery on deposit.

11. Giov. Batt. Cipriani, painter and designer, and a member of the Royal Academy, was born in 1727, at Florence, and died in 1787, curiously enough at Chelsea.

12. Mr. W. M. Rossetti thinks that H. T. Dunn antedates his first knowledge of Rossetti. He fancies the date was 1867 instead of 1863. His own first meeting with Dunn was, he says, at Howell's house, a few days before 21st May, 1867; and this he knows from his diary as recently published, *Rossetti Papers*, 1862-70. He is, besides, as good as certain that Howell was never in England between an early day in 1858 and some date in 1864. At the date given by H. T. Dunn of his first meeting with Rossetti, the latter had achieved a recognized position as a painter, and enjoyed, although a limited a by no means inconsiderable repute as a poet. He was a non-exhibiting painter, however; in the early years of his artistic career he determined to absolutely

refrain from exhibition, and to this resolve he remained faithful.

13. If 1867 was the actual year of the meeting, his age was then 39. "Gabriel Charles Dante Rossetti, who at an early stage of his professional career modified his name into Dante Gabriel Rossetti, was born on 12th May, 1828, at No. 38 Charlotte Street, Portland Place, London. In blood he was three-fourths Italian, and only one-fourth English; being on the father's side wholly Italian (Abruzzese), and on the mother's side half Italian (Tuscan) and half English. His father was Gabriele Rossetti, born in 1783 at Vasto, in the Abruzzi, Adriatic coast, in the then kingdom of Naples. Gabriele Rossetti (died 1854) was a man of letters, a custodian of ancient bronzes in the Museo Borbonico of Naples, and a poet; he distinguished himself by patriotic lays towards the date of the grant of a Constitution by Ferdinand I. of Naples in 1820. The King, after the fashion of Bourbons and tyrants, revoked the constitution in 1821, and persecuted the abettors of it, and Rossetti had to escape for his freedom, or perhaps even for his life. He settled in London towards 1824, married, and became Professor of Italian in King's College, London, publishing also various works of bold speculation in the way of Dantesque commentary and exposition. His wife was Frances Mary Lavinia Polidori (died 1886), daughter of Gaetano Polidori (died 1853), a teacher of Italian and literary man who had in early youth been secretary to the poet Alfieri, and who published various books, including a complete translation of Milton's poems. Frances Polidori was English on the side of her mother, whose maiden name was Pierce."— PREFACE, by Mr. W. M. Rossetti, to *The Collected Works of Dante Gabriel Rossetti.*

14. "The prevailing expression of" his "face"

was "that of a fiery and dictatorial mind concentrated into repose."—*Ibid*. In the February of 1862, Rossetti was overwhelmed with grief and dismay by the death of his wife. "He was always and essentially of a dominant turn, in intellect and temperament a leader. He was impetuous and vehement, and necessarily therefore impatient; easily angered, easily appeased, although the embittered feelings of his later years obscured this amiable quality to some extent . . . in family affection warm and equable and (except in relation to our mother, for whom he had a fondling love) not demonstrative. Never on stilts in matters of the intellect, or of aspiration, but steeped in the sense of beauty, and loving, if not always practising, the good . . . and anti-scientific to the marrow. Throughout his youth and early manhood I considered him to be markedly free from vanity, though certainly well-equipped in pride; the distinction between these two tendencies was less definite in his closing years . . . good-natured and hearty without being complaisant or accommodating; reserved at times, yet not haughty; desultory enough in youth, diligent and persistent in maturity; self-centred always, and brushing aside whatever traversed his purpose or his bent."— PREFACE, by Mr. W. M. Rossetti, to the *Collected Works*.

In 1870 Rossetti published his volume of *Poems*. "For some considerable while it was hailed with general and lofty praise, chequered by only moderate stricture or demur; but late in 1871 Mr. Robert Buchanan published, under a pseudonym, in the *Contemporary Review*, a very hostile article, named *The Fleshly School of Poetry*, attacking the poems on literary and more especially on moral grounds. . . . The assault produced on Rossetti an effect altogether disproportionate to its intrinsic importance; indeed, it developed in his character an excess of sensitiveness and of distempered brooding which his nearest relatives and friends had never before surmised.

. . . Unfortunately, there was in him already only too
much of morbid material on which this venom of detrac-
tion was to work. For some years the state of his eye-
sight had given very grave cause for apprehension, he
himself fancying from time to time that the evil might
end in absolute blindness, a fate with which our father
had been formidably threatened in his closing years.
From this or other causes insomnia had ensued, coped
with by far too free a use of chloral, which may have
begun towards the beginning of 1870. In the summer
of 1872 he had a dangerous crisis of illness; and from
that time forward, but more especially from the middle
of 1874, he became secluded in his habits of life and often
depressed, fanciful, and gloomy."—*Ibid*.

15. " The appearance of my brother was to my eye
rather Italian than English, though I have more than
once heard it said that there was nothing observable to
bespeak foreign blood. He was of rather low, middle
stature, say five feet seven and a-half, like our father;
and, as the years advanced, he resembled our father not a
little in a characteristic way, yet with highly obvious
divergences. Meagre in youth, he was at times
decidedly fat in mature age. The complexion, clear and
warm, was also dark, but not dusky or sombre. The hair
was dark and somewhat silky; the brow grandly spacious
and solid; the full-sized eyes blueish-grey; the nose
shapely, decided, and rather projecting, with an aquiline
tendency, and large nostrils, and perhaps no detail in the
face was more noticeable at a first glance than the very
strong indentation at the spring of the nose below the
forehead; the mouth moderately well shaped, but with
a rather thick and unmoulded underlip; the chin unre-
markable; the line of the jaw, after youth was passed,
full-rounded and sweeping; the ears well-formed and
rather small than large. His hips were wide, his hands

and feet small; the hands very much those of the artist or author type, white, delicate, plump, and soft as a woman's. His gait was resolute and rapid, his general aspect compact and determined. . . . Some people regarded Rossetti as eminently handsome; few, I think, would have refused him the epithet of well-looking. . . . He wore moustaches from early youth, shaving his cheeks: from 1870, or thereabouts, he grew whiskers and beard, moderately full and auburn tinted, as well as moustaches. His voice was deep and harmonious; in the reading of poetry, remarkably rich, with rolling swell and musical cadence."—*Ibid.*

16. This painting does not represent the legendary and supernatural being named Lilith. It is an oil painting called *Lady Lilith*, to intimate that the work should be understood as depicting the allurements of physical beauty uncombined with moral beauty. Rossetti made of it some water-colour replicas and illustrated the picture by the following sonnet, which is now known as *Body's Beauty* :—

" Of Adam's first wife, Lilith, it is told
 (The witch he loved before the gift of Eve)
 That, ere the snake's, her sweet tongue could deceive,
And her enchanted hair was the first gold.
And still she sits, young while the earth is old,
 And, subtly of herself contemplative,
 Draws men to watch the bright web she can weave,
Till heart and body and life are in its hold.

" The rose and poppy are her flowers ; for where
 Is he not found, O Lilith, whom shed scent
And soft-shed kisses and soft sleep shall snare ?
 Lo ! as that youth's eyes burned at thine, so went
 Thy spell through him, and left his straight neck bent
And round his heart one strangling golden hair."

17. That Adam had a wife so named before the creation of Eve. According to Rabbinical mythology,

she was changed into a night spectre, especially hostile to newly-born infants. The legend had a peculiar fascination for Rossetti. He introduces the supernatural Lilith into his poem *Eden Bower*.

18. Walpurgis Night. Scene 31.

Faust. And who is that?
Mephistopheles. Do thou observe her well.
That's Lilith.

Faust. Who?
Meph. Adam's first damosel.
Be on thy guard against her lovely hair,
That tire of hers in which she peerless shines!
When with its charm a youngster she entwines,
She will not soon release him. So beware!
Webb's Translation.

19. Mr. William M. Rossetti has already expressed his own opinion that the alteration referred to was detrimental to the work. Fortunately a photograph of the painting in its original state exists. When Rossetti re-painted the face, he employed a different model.

20. This picture has often been called the *Dying Beatrice*, but not with strict correctness. Its true title is as given. It represents Beatrice in a trance, which is to be understood as symbolically suggesting death, but she is not intended to be really dead, nor yet dying.

21. She had at an earlier date been Mrs. Cowper-Temple. Mr. W. M. Rossetti, in speaking of the extremely cordial relations which subsisted between his brother and the principal purchasers of his pictures, expressly mentions this lady as one of his friends.

22. See Note 12. February, 1862. After a lengthy engagement, Rossetti, in the spring of 1860, married Elizabeth Eleanor Siddal, originally a milliner's assistant, and the daughter of a Sheffield cutler. As will be seen, their wedded life was of short duration. She had given birth to a still-born infant. Miss Siddal was gifted with

considerable artistic and poetic fancy herself. She produced several water-colours and designs which, albeit based upon her husband's style, display genuine originality and some considerable skill.

23. This is a picture of a single female half-figure, now in the possession of Mr. T. H. Ismay.

24. Poet, engraver, and painter, 1757-1827. In reciting the names of those poets whose influence tended to nurture the mind of his brother, and helped to educe its own poetic endowment, Mr. W. M. Rossetti mentions the name of Blake as receiving his peculiar meed of homage.

25. Mr. W. M. Rossetti has kindly drawn attention to the fact that this book contained a number of miscellaneous designs by no means limited to such as apply to the *Songs of Innocence*. There were also a great many writings in verse and prose in it.

26. 1847.

27. Biographer, 1828-61. Wrote the *Life of Blake*. Rossetti was intimate with and had a deep esteem for him. He died as he was approaching the end of his excellent and now fully-appreciated labours on the *Life*, which was originally published, with selections from Blake's poems and other writings in 1863. Another edition appeared in 1880.

28. The author of these Recollections errs in assigning a collaboratorship to Rossetti. Rossetti supplied Gilchrist with some valuable material, but not with any contributory writing of his own. Having died before the book was published, but not before it was substantially completed, his widow, Anne Gilchrist, prepared it for the press. But as she considered it expedient to avail herself of Rossetti's assistance in certain defined portions of the work, he undertook all the editing of Blake's writings in

prose and verse which form Vol. II. He is also credited with certain passages in Vol. I. In the *Collected Works of Dante Gabriel Rossetti*, Mr. W. M. Rossetti gives the remarks of his brother upon the poems; preceded by the supplementary chapter which he made to the *Life*, and followed by his comments upon the designs to the *Book of Job*, and upon certain points connected with the designs to the *Jerusalem*. The large majority of these observations appeared in the original edition; part of the *Jerusalem* section belongs only to that of 1880. A few of the opening phrases in the supplementary chapter must, Mr. W. M. Rossetti thinks, be Gilchrist's own, but he has not been at the pains of detaching them. Nothing else of any substantial bulk or importance was, he says, written by his brother for Gilchrist's book.

29. This statement goes too far. At a time when he knew nothing about the MS. book, nor yet about Rossetti, Gilchrist undertook to write the *Life*, and wrote a good deal of it. Afterwards, knowing Rossetti and the book, he fairly completed it, but not absolutely, as he died suddenly.

30. By Colonna, *circa* 1490.

31. Mr. W. M. Rossetti observes here, that the designs seem quite unlike Botticelli's, and that Giovanni Bellini has, with less obvious improbability, more generally been suggested. His own view, however, is that connoisseurs regard the authorship of the designs as extremely uncertain.

32. Poet and critic, author of *Fine Art*, &c., the third child and second son of Gabriele Rossetti, born in 1829. There were four children altogether, all honourably known in connection with Literature and Art, namely, Maria Francesca, author of *A Shadow of Dante*, Dante Gabriel, William Michael, and Christina, the

author of *Goblin Market*, *The Prince's Progress*, and other works in prose and verse.

33. Painter and etcher, 1835-1903. President of the Society of British Artists 1886-1888. An artist friend of Rossetti's.

34. Specimens of China porcelain in which figures of slim Chinese ladies are painted. Mr. W. M. Rossetti points out that the correct phrase is " Lange leises "— *i.e.*, long (tall or slim) damsels—this being the name given to porcelain of the kind by the Dutch. It is written in the manuscript of the Recollections as printed, and no doubt the proper phrase has often been so corrupted. Possibly here a witticism of Whistler's may be detected.

35. Mr. W. M. Rossetti doubts these figures. He rather thinks that Rossetti gave more than £120 for the pair (say £200), and his belief is that on their being sold by him to the dealer he had bought them of, he only received the same price which he had given.

36. In 1848, Rossetti co-operated with two of his fellow-students in painting, John Everett Millais and William Holman Hunt—his leading colleagues—and with the sculptor, Thomas Woolner, in forming the so-called Præ-Raphaelite Brotherhood. There were three other members, James Collinson, Frederic George Stephens, and William Michael Rossetti. The words of the latter will best describe the movement :—" A great deal of discussion has arisen from time to time as to what were the motives of these young men in forming their association, and why they called themselves Præ-Raphaelites . . . In the briefest terms . . . the movement was partly one of protest and partly one of performance; protest against the general intellectual flimsiness and vapid execution of British Art in those

days, and performance in the way of serious personal thought in invention and design, and serious personal minute study of Nature as the solid substratum of all genuine execution. The name "Præ-Raphaelite" was adopted, not because the young men wanted to imitate early and immature works of art (which, in fact, they never did), but to indicate that they would not be hidebound by any rules or traditions, Raphaelite or Post-Raphaelite, which they might not find ratified by visible nature and their own minds. From the very beginning of the movement, the men painted in styles differing the one from the other, although with some common principles of work to found upon; and after some four years of association they sundered, each on his own track. Millais became justly celebrated for facile and striking realism, somewhat obvious in point of thought; and Holman Hunt for strenuous well-pondered purpose and unflinching precision of execution. Rossetti, on the other hand, pursued beauty as his main object, combined with ideal or symbolic suggestiveness.

37. Painter, 1829-1896; A.R.A., 1853; R.A., 1863; P.R.A., 1896; created a baronet, 1885. As already implied, he and Rossetti were fellow-students together at the Royal Academy—Millais in the Painting School, Rossetti in the Antique School. He was on terms of unrestricted intimacy with Rossetti in youth, as were all the Præ-Raphaelites, but, owing to death and other causes, Rossetti lost sight of all of them, except Stephens, eventually.

38. Painter, 1827. Also a fellow-student of Rossetti's at the Royal Academy, and the third Præ-Raphaelite.

39. Sculptor and poet, 1826; A.R.A., 1871; R.A., 1876; Professor of Sculpture in the Royal Academy, 1877-79; the fourth Præ-Raphaelite.

40. Poet, painter, and etcher, 1811. Author of *Poems by a Painter*, &c. His autobiographical notes were published in 1892, soon after his death.

41. Painter, 1821-93. Alluded to by Mr. W. M. Rossetti as, first and foremost, his brother's chief intimate through life, " on the unexhausted resources of whose affection and converse he drew incessantly for long years." Ford Madox Brown bore an important part in directing Rossetti's studies, and greatly influenced for good his subsequent life. They became acquainted a few months before the time the Præ-Raphaelite scheme was put forward. Although he did not think fit to join the Brotherhood in any direct or complete sense—because he disbelieved in the advantages of cliques—he bore a weighty part in supporting the movement, and did more than any other to sway its members. And he always felt a keen sympathy towards the aspirations he largely assisted to mould. The friendship existing between Brown and Rossetti, which almost amounted to brotherhood, and extended over the latter's after life, was formed in this way. In March, 1848, Rossetti, who had been profoundly struck with his work, wrote Brown for permission to attend his studio as a pupil, warmly extolling his paintings, and adding that if he ever did anything on his own account, it would be under the influence of his inspiration. Brown courteously granted the request which had been made, and accordingly Rossetti entered his studio, not as a paying pupil, but as a friend. They were ultimately separated by Brown's removal to Manchester for the purpose of executing the frescos in the Town Hall there.

42. Poet and musician, born somewhere towards 1850, and living abroad, whither he went several years ago. About 1875, he published a volume of poems which, although rather odd, display much ability. He

then became more noted in musical matters, and was a semi-professional vocalist.

43. The Liverpool shipowner, of Prince's Gate, now deceased. He was one of the principal purchasers of Rossetti's pictures. Rossetti stood towards him in an extremely friendly relation. Whistler painted for Leyland the famous " Peacock Room," and then quarrelled with him.

44. The taste of the collector, by which Rossetti was always strongly influenced, asserted itself at an early age.

45. One of the famous " Thames Series " of plates, a series which contains the finest etched plates of modern times. Whistler came to London about 1862, and, on discovering the artistic charms of Chelsea, he also went to reside there.

46. An acknowledged and daring epigrammatist, Whistler's sayings were always a source of unbounded amusement to his friends. " Why bring in Velasquez ? " is perhaps the most characteristic of his replies, which was addressed to a gushing lady who had insisted on assuring him that he and Velasquez were the greatest painters of this or any age.

47. Art and miscellaneous writer, 1819—1901. In after times he became an eloquent and stedfast advocate of the Præ-Raphaelites. Rossetti was extremely intimate with and derived much help from him in his professional career.

48. Poet, 1812-1889. In enumerating the various poetic influences to which Rossetti was subject, his brother says :—" Lastly came Browning, and for a time, like the serpent-rod of Moses, swallowed up all the rest. This was still at an early age of life ; for I think the year 1847 cannot certainly have been passed before my brother

was deep in Browning. The readings or fragmentary recitations of *Bells and Pomegranates*, *Paracelsus*, and, above all, *Sordello*, are something to remember from a now distant past " (PREFACE to the *Collected Works*). Browning's poems furnished Rossetti with subjects. His first water-colour painting, an illustration to Browning's *Laboratory*, was painted as early as 1849. About the year following, Rossetti made the personal acquaintance of Browning, of whose poetry he was one of the first appreciators, and a genuine and friendly intercourse, extending over several years, ensued. One day, Rossetti saw in the British Museum *Pauline*, which had been published anonymously; he identified it with Browning, and ventured to write to the great poet to tell him so. He received a cordial response, and thus their friendship came about.

49. Poet and critic, 1837, a staunch, fervent, and sympathetic friend of Rossetti's. As already noted, he originally occupied certain apartments at No. 16, Cheyne Walk. Rossetti first became aquainted with him in 1857, when he was known among his intimates to be a youth of brilliant promise. He rose towards celebrity from 1861, in which year his first poetic volume was published. When the poet-painter and Edward Burne-Jones were at work on the paintings at the Union Club, Oxford, Swinburne entered the room with Mr. (afterwards Dr.) George Birkbeck Hill, who introduced him to Rossetti. For Swinburne Rossetti had a very friendly and affectionate feeling, which continued undiminished up to the latter's death, although he lost sight of him towards 1872.

50. Poet, artist, and socialist, 1834-96. Another true, ardent, and sympathetic friend of Rossetti's. They became acquainted through Burne-Jones and, as in the case of Swinburne, Rossetti had a warm and friendly

feeling for Morris, which continued right up to his death, although they did not meet after 1877. As already noticed, they jointly occupied Kelmscott Manor, and, as mentioned in the Recollections, they were for some time associated in business.

51. Poet, 1809—1892. According to his brother, in the mind of Rossetti when he was quite a youth and hardly out of boyhood, Tennyson reigned along with Keats, and Edgar Poe and Coleridge along with Tennyson.

52. This is a somewhat well-known incident, the details of which have already been accurately published by Mr. W. M. Rossetti and others. The latter thinks there was one other person present—possibly Ford Madox Brown.

53. The original sketch, as made on the spot, was presented to Browning, and, it is presumed, is now owned by his son. Rossetti made one or two copies, and one version is in the possession of his brother.

54. Rossetti made a very large number of drawings of her from 1850 onwards, and especially between 1853 and 1857. In the Victoria and Albert Museum there is one in pen-and-ink, in which she is depicted standing.

55. It was a long-cherished project of Rossetti's to bring out a volume of original poems in or about 1862, but its fulfilment was delayed until 1870 through a strange and romantic incident. His affection for his wife was very deep, and when, after a short period of married life, she died, he was so distraught with grief that he resolved to sacrifice his scheme to her memory, and accordingly buried in her coffin the MSS. of the poems. He was pressed in subsequent years to have them exhumed, and as time went by, he was persuaded that the sacrifice was neither necessary nor desirable. In 1869 the manu-

scripts were recovered and published in the following year. Howell undertook the task of exhumation; all was found as originally left, although the manuscripts had to undergo a long process of disinfection before they could be made use of.

56. Morris, Marshall, Faulkner, and Co.

57. Painter, 1833-98, A.R.A. 1885, created a Baronet, 1894. A staunch and sympathetic comrade of Rossetti's, whose influence was always strong upon him. He originally intended to enter the Church, but coming under the sway of Rossetti at Oxford, he abandoned the idea and adopted painting as a profession. Rossetti's disposition towards him was always cordial and affectionate, and he kept in close touch with him almost to the last.

58. It is uncertain where this series exists in glass.

59. The designs of the *Parable* were executed for the church of S. Martin-on-the-Hill, Scarborough. The series begins with the Labourers of the Vineyard, and ends with the procession of the rebellious vineyard workers to punishment.

60. Some of the *St. George and the Dragon* series, perhaps all, were turned into water-colour pictures (and bought by the late Mr. Geo. Rae, of Birkenhead); but Mr. W. M. Rossetti is strongly of opinion that this was not done with the *Parable* series.

61. Into his first exhibited painting, hereafter noted, Rossetti introduced the portraits of his mother and his sister Christina. In the first of his *Three Designs from Tennyson's Poems*—" Mariana in the South "—the face of his wife is seen; again, with that of his sister, in the second—" King Arthur ' watched by weeping Queens ' in the vale of Avalon "; and again in the third —" S. Cecilia." *Queen Guinevere* (now in the Dublin

National Gallery) is the first, or very nearly the first, head that Rossetti drew from Mrs. Morris.

62. Mr. W. M. Rossetti here remarks that this is not quite correct. The person who drops the stone is of quite different physique from Morris, he says, and bears some resemblance to Val Prinsep. The head of Morris occurs, however, in the same design; he is putting his head out through a wicket, wearing a smile of hypocritical civility, whilst the other man, his accomplice, casts down the stone.

63. The painter's brother fails to recognise Morris in the last of the set at all.

64. A Belgian who was famous as a picture dealer in London from *circa* 1850 until 1875, when he retired and became Consul for Spain at Nice. He died at a great age about 1902, and his pictures, &c., were recently sold at Christie's.

65. "Among the works of importance between which and the poems no direct connection can be traced, a few stand prominently forward. Formost amongst these is this triptych. The various divisions of this are curious as exemplifying the boldness with which, at this period, and subsequently, Rossetti threw off the trammels of Præ-Raphaelitism, and, while adhering to the mysticism, the recurrent phases of which màrk his entire life, hesitated not to employ costume and effects which commended themselves by picturesqueness and beauty rather than by archaic correctness. In richness of colouring and in impressiveness this work remains one of the most striking oil paintings of Rossetti's middle period."—*Life of Dante Gabriel Rossetti*, by Joseph Knight.

66. It has been pointed out by Mr. W. M. Rossetti, that this Gallery was not instituted by the Præ-Raphaelites in 1849, but that it began a year or two

earlier, and had nothing to do with the Præ-Raphaelites, except that Rossetti and Ford Madox Brown exhibited there two or three times.

67. The full title of this picture is the *Girlhood of Mary Virgin*. It was painted late in 1848 and in the Spring of 1849, and shewn in the latter year. The first completed oil picture of Rossetti's is a head of Christina Rossetti (June, 1848); then began the *Girlhood of Mary Virgin*, and then, before this was finished, came the head of Gabriele Rossetti (October, 1848). The tutor of the B. Virgin (it is the Annunciation lily, of course, which she is embroidering) in the picture under notice, is not S. Elizabeth, but S. Anna, the mother of Mary; in the background occurs her father, S. Joachim. The head of the B. Virgin is that of Rossetti's sister Christina; that of S. Anna was done from his mother. In this picture the mystic adoration and faith of mediævalism is wonderfully and finely realized.

68. *Cordelia at the Bedside of Lear*—Rossetti sat for the head of the fool. The picture now belongs to Mrs. Rae, of Birkenhead.

69. This bed, in which Rossetti was born, had belonged to his father and mother, but was now the property of the painter.

70. First published in the early months of 1850. It was brought out by the Præ-Raphaelites with the co-operation of some friends, and afterwards called *Art and Poetry*.

71. The first verses and the first prose published by Rossetti. He contributed various other poems also.

72. And the *Blessed Damozel* likewise.

73. *Poems* by Dante Gabriel Rossetti (London, 1870), not the *Ballads and Sonnets* (1881), which Henry T. Dunn evidently had in mind.

74. Painter, and one of the Præ-Raphaelite Brotherhood, his membership of which, however, after a short time he resigned.

75. A disciple of the Præ-Raphaelites, and an artist of considerable skill, who died prematurely.

76. A leading Greek family in London. Constantine Ionides bought many pictures by Rossetti and others, and has left the whole collection to the Victoria and Albert Museum.

77. Solicitor and picture buyer, who died towards 1887.

78. Now Earl of Carlisle; an amateur painter and a friend of Burne-Jones.

79. An early associate of Rossetti's; he first knew Rossetti towards 1852, and was one of the earliest purchasers of his works. He was at first studying as an architect, but changed to landscape-painting, and produced many excellent water-colour landscapes, fine in feeling and colour, without much ambition in subject. He was a member of the old Water-colour Society and died towards 1900.

80. Etcher, painter, and caricaturist, 1792-1878.

81. Landscape painter; one of the first to follow the Præ-Raphaelite lead. He died towards 1890, and has a picture in the National British Gallery.

82. Rossetti was always intensely superstitious in grain. According to his brother, any writing about devils, spectres, or the supernatural generally, whether in poetry or prose, had a fascination for him; at one time— say 1844—his supreme delight was the blood-curdling romance of Maturin, *Melmoth the Wanderer*.

83. According to the same authority, Rossetti, from an early period of life, had a large circle of friends, and

could always have commanded any amount of intercourse with any number of ardent or kindly well-wishers. He was constant and helpful as a friend, where he perceived constancy to be reciprocated; free-handed and heedless of expenditure, whether for himself or others; extremely natural, and therefore totally unaffected in tone and manner. He was very generally and very greatly liked by persons of extremely diverse character, and it might almost be said that no one ever disliked him.

84. A distinguished painter and designer, still living at an advanced age. He has done some excellent portraits and fine woodcut designs. One of his principal works is an oil picture, *Medea*.

85. Journalist and miscellaneous writer, 1828-1895.

86. LL.D. Poet and dramatist, 1819-1890.

87. Rossetti was keenly alive to the laughable as well as the grave or solemn side of things, and had on the whole a sufficiency of high spirits. These were much affected in and after the Spring of 1872, in consequence of the publication of Robert Buchanan's attack in pamphlet form, and the exaggerated or morbid ideas which Rossetti conceived on the subject.

88. 1871-4.

89. Still alive; now Mrs. Guppy Volckman.

90. Of Barnard Castle.

91. An extremely celebrated medium, now deceased. A famous action was heard against him, which he lost. Mr. W. M. Rossetti does not think his brother ever saw him.

92. An Austrian, of early middle age at this time, who spoke English well, and who, it will be seen, gave some surprising demonstrations at Rossetti's house. He

does not appear to have been professionally connected with spiritualism. Mr. W. M. Rossetti saw him once at Cheyne Walk.

93. Sir Coutts Lindsay, founder of the Grosvenor Gallery.

94. Poet and critic, the author of *Aylwin* (*b.* 1836). His "intellectual companionship and incessant assiduity of friendship did more than anything else towards assuaging the discomforts and depression of his closing years," writes Mr. W. M. Rossetti, in reference to Mr. Watts-Dunton's association with his brother. They became acquainted through Dr. Hake, the poet, and Rossetti died in his friend's presence, April 9th, 1882. Mr. W. M. Rossetti considers that it must be through a defect of memory Mr. Watts-Dunton is stated to have been present at this mesmeric entertainment. That affair, it seems to him, was probably not later than 1871, and Mr. Watts-Dunton was not known to Rossetti until late in 1872.

95. Sir Richard Burton, 1821-1890.

96. Of the "Road Murder." She was the daughter of a man reported to be a natural son of the Duke of Kent, and therefore a half-niece of Queen Victoria. At the age of fifteen or so she murdered, out of spite, a brother (or half brother) of hers, aged perhaps three. She was not known to be the murderess, but after some four or five years she confessed it, having come under religious influences. She pleaded guilty and was sentenced to death, but the sentence was commuted. When sentenced, she was, of course, regarded as sane; it is doubtful if she was ever considered otherwise or detained at Broadmoor.

97. 10th June, 1840.

98. He made a considerable reputation as a painter towards 1845. At one time he was confined in Bedlam, where Mr. W. M. Rossetti once saw him.

99. Mathematician and astrologer, 1527-1608.

100. It is implied here that the name of the poem is *Beryl*. This is not the case. The title is *Rose Mary*. The author of these Recollections refers to the *Beryl-Songs* so entitled, which follow the three divisions of the poem, concerning which Mr. W. M. Rossetti writes:—"This poem was written in the early autumn of 1871. The *Beryl-Songs* are a later addition, say 1879. The very general opinion has been that they were better away, and I cannot but agree with it. I have heard my brother say that he wrote them to show that he was not incapable of the daring rhyming and rhythmical exploits of some other poets. As to this point, readers must judge. It is at any rate true, that in making the word ' Beryl ' the pivot of his experiment, a word to which there are the fewest possible rhymes, my brother weighted himself heavily."—NOTES to *Collected Works of Dante Gabriel Rossetti*.

"Rose Mary is regarded by many as the author's highest poetic accomplishment. It is, at least, a magnificent ballad, using, with unrivalled effect a mystical Eastern conception, and charged with the subtlest and the most poetical significance."—*Life of Dante Gabriel Rossetti*, by Joseph Knight.

101. She is represented in Hades, holding the pomegranate, of which (according to mythological legend) she ate a single seed, and was thereby interdicted from returning to earth. Of this subject, there are two oil-paintings, about equally successful.

102. Rossetti painted two rather large oil pictures from his poem *The Blessed Damozel*—one for Mr. Graham,

circa 1875, the other for Mr. Leyland, *circa* 1878. In the earlier and better of the two, groups of lovers re-united in heaven are introduced in the background, but not in the other.

103. Daughter of Priam, King of Troy, who possessed the gift of prophecy. Apollo ordained that she should be discredited. She was captured, on the fall of Troy, by Agamemnon, and executed at Mycenæ by Clytemnestra. The picture shows Hector sallying forth to his last fatal battle, and his sister prophesying his death. Helen, who is arming Paris, is incensed at some words which Cassandra has let fall concerning her. As the princess, though she always presaged the truth, was never credited, her brother Deiphobus is endeavouring to silence her.

104. Mr. W. M. Rossetti points out that the date of this incident could not be later than 1868 or so, and that the *Proserpine* picture was not painted until 1872 or 1873, and cannot have been at Cheyne Walk till late in 1874. After it was painted, he doubts if Swinburne was ever once in the house, and says the same remark applies still more strongly to *The Blessed Damozel* picture. There might, however, he adds, have been some drawings of both subjects in the studio, and it is to these, perhaps, the author of these Recollections refers.

105. Painter, b. 1841, d. 1902.

106. See Note 28.

107. Edward Hughes, painter, and nephew of Arthur Hughes, another good painter.

108. The Rev. Charles Lutwidge Dodgson, b. 1832, d. 1898.

109. Henry Wadsworth Longfellow, American poet, 1807.